COLLINS

CALLIGRAPHER'S COMPANION

COLLINS
CALLIGRAPHER'S COMPANION

Mary Noble
&
Janet Mehigan

HarperCollins*Publishers*

A QUARTO BOOK

Copyright © 1997 Quarto Publishing plc

Collins Calligrapher's Companion

First published in 1998 by
HarperCollins*Publishers*
London

04 03 02 01 00 99 98
10 9 8 7 6 5 4 3 2 1

ISBN 0 00 413378 1

This book was designed and produced by
Quarto Publishing plc
The Old Brewery
6 Blundell Street
London N7 9BH

Senior editor Kate Kirby
Editor Jean Coppendale
Art editors Toni Toma, Dave Kemp
Designer Hugh Schermuly
Picture researcher Miriam Hyman
Photographers Paul Forrester, Les Weis
Art director Moira Clinch
Editorial director Pippa Rubinstein

Typeset by Central Southern Typesetters, Eastbourne
Manufactured in Hong Kong by Regent Publishing Services Ltd
Printed in Hong Kong by Sing Cheong Printing Co. Ltd

Contents

Calligraphy today

The revival of interest in calligraphy in the Western world really began with the work of Edward Johnston (1872–1944). Johnston studied at the British Museum in London where he analyzed how old manuscripts had been written, the tools that were used, and the different angles of the pens. He created the foundational hand we use today and taught many students who became highly skilled calligraphers.

There is now a more liberal approach to design and letterform. Working within the vast advertising empires has allowed the more innovative and creative calligraphers to push back the boundaries. Calligraphy is now being developed into an art form and is a platform for making challenging statements, creating feelings about the language of words and letters, and expressing poignant poetry and prose. With the introduction of the color camera, four-color printing, color photocopying, and computers, there are hundreds of ways to present new letterforms. The world of graphics and advertising relies on the color sciences and the "feel and expression" of words, rather than just information. New images, concepts, and shapes increase interest and excitement, communicate ideas, and sell products.

Computerized lettering can be stretched, turned, made heavier, faded in and out; it can be enlarged and reduced, and made to create mood, express action, insinuate feeling.

Today the skilled calligrapher is continually adding new vitality to letterforms. The production of beautiful formal manuscripts and the commercial world of graphics both rely on the interpretation and feel of words, and the myriad possibilities of new shapes and images are endless.

We accept the written word as such basic knowledge that we observe the printed, computerized, or hand-written words with little thought of the arranged alphabetic elements beyond the message that it conveys. It surrounds us in everyday life in newspapers and books, on television, on commercial packaging, and as signwriting on boards and fascias.

The alphabet

The history of the alphabet is long and complicated, beginning over 20,000 years ago with the painted pictures created in caves, and evolving slowly to symbols of various forms modified by the social and technical changes that occurred. The Phoenicians created the first alphabet in about 1200 B.C., which in turn was developed in 850 B.C. by the Greeks and then the Etruscans who, when they invaded Rome in the 7th century B.C., took their alphabet with them. When the Romans superceded their rule in the 3rd century B.C., they had modified the alphabet to almost what we see today, with the exception of three letters J, U, and W. (I and V served as dual letters for J and U, and W did not exist.)

The Roman alphabet has been in existence for over 2,000 years, yet its visual form has varied, changed by the writing tools employed and the social and economic environment in which it has been written. The best known

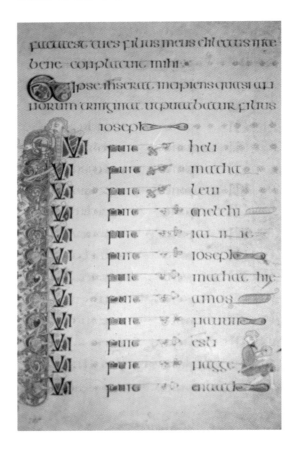

The Book of Kells, showing a superb example of insular half-uncials. Written by Irish scribes in the 8th century. ▲

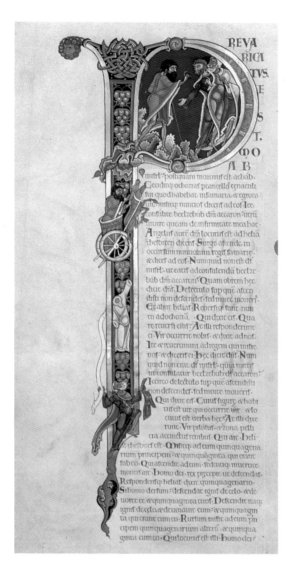

The Winchester Bible, dating from the 12th century. This is an example of late Carolingian script showing the beginnings of Gothic compression. Versal capitals in red and blue can be seen at the top of this expertly decorated letter. ◀

The Luttrell Psalter is a fine example of Gothic Prescissus, a textural and condensed text with its "flat feet" on the bottom of letters. It was written and illuminated in England between 1325–35. ▲

Roman alphabet, the Inscriptional Capital (Imperial Capital), was used both in stone-carved and brush-written letters and can still be seen on monuments such as Trajan's Column (A.D. 113). Formal writing on papyrus scrolls for manuscripts, documents, signs, and notices were in the form of Rustics written with a brush or reed. Romans also used a cursive, everyday hand for informal documents and accounts, and for use on wax tablets using a stylus. These different scripts had become standard by the 1st century A.D. Square Capitals written as a book hand on vellum were evident by 4th century A.D.

Papyrus scrolls, expensive to import from Egypt and difficult to handle, were gradually replaced by the codex (book), and the use of animal skin was developed. As parchment and vellum became the standard material in Western countries for books, the use of the quill pen, usually goose, became more widespread.

Letter shapes became rounder because of the way this tool marked the material and the speed of writing. These letters are known as Uncials.

Uncials and half-uncials

Uncials appeared in the 4th century A.D. and became the main Roman book hand until the 8th century A.D., and for headings until the 12th century. During this time, there were many variations written throughout Europe, including the later used half-uncial. These letters were capitals, although D, F, G, H, K, L, and P show the first suggestion toward the ascenders and descenders used in the minuscule (lower case letters). Britain developed its own style of writing which was influenced by the monks who came over from Ireland. As book production increased, writing became faster and less formal, ascenders and descenders became longer, producing a hand we call insular half-uncial which was used in the Book of Kells.

Carolingian minuscule

Charlemagne, King of the Franks, A.D. 768–814, and crowned Emperor of Rome in 800, governed a vast area of land stretching from Italy and Spain in the south throughout Germany and

An example of printed Gothic from the Gutenberg Press. A 15th century book with hand-painted initial letters and border decoration. ▲

EVERY SCRIBE INSTRUCTED IN The kINGdom of heaven is like a householder who BRINGS FORTH out of his treasury NEW Things and old

mATThew XIII:52

A modern Roman uncial written by Gareth Colgan. ◄

Europe. For Western civilization, this was the beginning of a great cultural revival. Charlemagne was Christian, literate and a great lover of books and classical learning. He issued a decree to form all liturgical books throughout his kingdom and invited many learned men to his court to fulfil this task. He appointed Alcuin (A.D. 735–804) Head of the Cathedral Schools of York to become Master of the Court School of Aachen. The script used at the court of Charlemagne was Carolingian or Caroline minuscule (lower case), an elegant hand developed from the half-uncial, but with a slight forward slope which was used far into the 11th century. A hierarchy of scripts during this standardization of books developed. Titles were in Roman capitals, opening lines in uncial or half-uncials, with additional lines often in Rustics, but the main area of text was in Carolingian minuscule. Capital letters within the text were generally uncial.

Versals

The earliest books consisted of continuous writing in capital letters with few spaces in the text. Later, larger capitals were used to give emphasis to headings and beginnings of verses. The shapes and proportions were based on Roman Inscriptional Capitals, and they were drawn quickly and skillfully with the pen. The finest examples were from the 9th and 10th centuries and often colored in red and blue as in the Winchester Bible.

Beginnings of Gothic

During the 11th and 12th centuries, the written letter became more compressed and the decoration more elaborate with illuminated and historiated initial letters within the text. The artists for these books traveled the continent, moving from monastery to monastery as the work required.

There was a great demand for books not only by the Church, but also by the laity and universities. By the 13th century, craft workshops had become established in cities such as Paris, Bologna, Winchester, Oxford, and York, employing professional scriveners. The letter shapes became more compressed, probably due to the fashionable architectural and artistic styles of the day and the need to economize on the materials used in book production.

Gothic or "Black Letter"

The Gothic or "black letter" emerged with great variations throughout Europe. Northern

Europe used Quadrata, a textural angular hand with "diamond" shaped feet. In England the scribes were busy using a compressed Gothic with "flat feet," Gothic Prescissus, constructed by either turning the pen at the end of the letter stroke or filling it in with the corner of the pen. Gothic (Textura) became very compressed, creating a heavy texture on the page. It was slow to write and difficult to read. The letters were based on the angular compressed "o" shape, with identical close spacing within and outside each letter.

During this time a more cursive Gothic called Bâtarde was being used in France and in Germany, Fraktur, again a cursive Gothic, but written upright and with the heaviness and rigid feel of Textura.

Southern Europe, Italy, and Spain disliked the heavy Northern European Gothic and used a rounder, more open form, named Rotunda.

During the Italian Renaissance, A.D. 1400–1500, there was a rebirth of interest in classical learning, which inspired the Italians to rediscover the Caroline minuscule. From this they created the Humanist script and the beginnings of Italic.

Following the invention of the printing press, printers had many styles of lettering from which they could choose. Many printed books were in Gothic, but in Italy they became more interested in the Classical Roman, Caroline, and Humanistic hands for type. These are the basis of our modern typefaces, and many still carry their names, such as Palatino and Bodini. Italian scribes revived the Roman Square Capitals, and many manuscripts written in Italy from 1450 contained pages with these elegant letters, many of which were executed by the Paduan scribe Bartolomeo San Vito, who developed his own inimitable style.

Italic

Italic was the descendant of Humanist script. It was written with more speed to produce a slight slant and fewer pen lifts, which resulted in an elegant, flowing letter. Modern variations are endless.

Copperplate

After the Renaissance, writing with an edged pen declined and was superceded by copperplate, which was done with a pointed quill. From the 17th to the 19th century, copperplate was widely used in both industry and commerce. At its best it was beautiful, and at its worst it became over ornate.

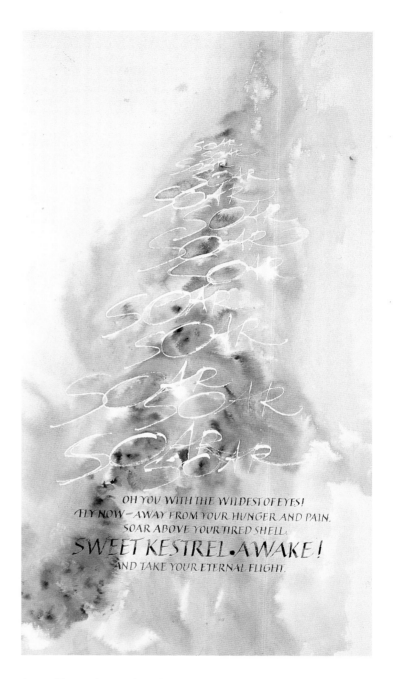

An exciting and evocative piece of calligraphic writing and illustration in modern italic capitals by Penny Price. ▲

Foundational

As we come to the end of the 20th century, one hundred years since Edward Johnston created Foundational hand, it seems inconceivable that the alphabet will change its present form, yet history dictates that this is inevitable. Possibilities for new shapes, new ideas, and images are endless, making calligraphy and working with letters continuously exciting and stimulating.

stuvux

ABCD

FGH

Getting Started

Tools and materials

*W*hen starting calligraphy the immediate essentials are a dip pen, paper, non-waterproof ink, and a board. However, before long, you may wish to obtain some additional equipment: pencils; eraser; "T" square (for easy line drawing); different pen nibs; colored paints or inks.

Extra items can be added gradually and, if it is properly cared for, your equipment should last a long time. Nibs and reservoirs should be removed, and washed and dried carefully. Brushes can be rinsed in cold water, repointed, and stored hair uppermost in a jar. When mixing paint use cheap nylon or old brushes to prevent wear on your best brushes. All equipment should be kept clean and stored well for best results.

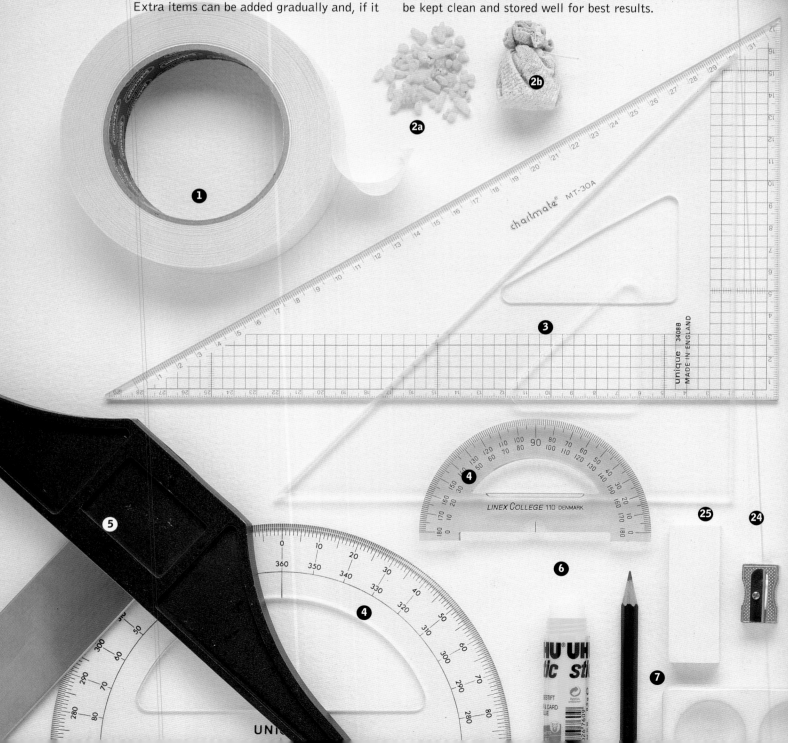

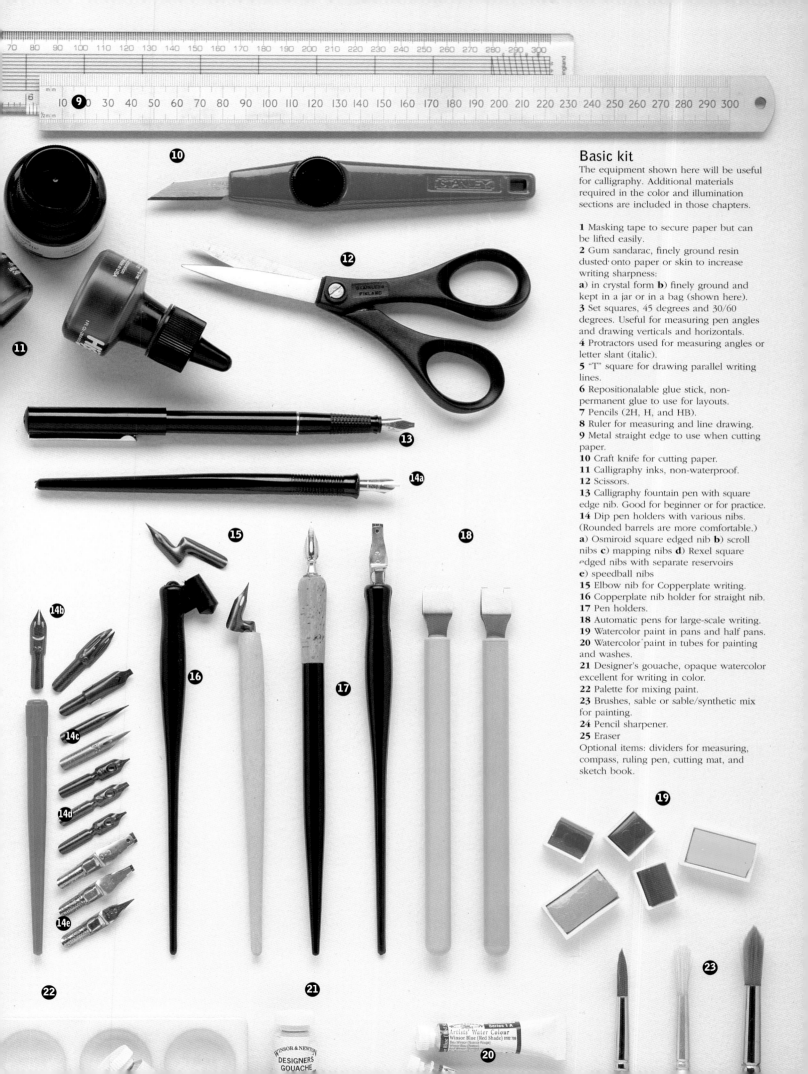

Basic kit

The equipment shown here will be useful for calligraphy. Additional materials required in the color and illumination sections are included in those chapters.

1 Masking tape to secure paper but can be lifted easily.
2 Gum sandarac, finely ground resin dusted·onto paper or skin to increase writing sharpness:
a) in crystal form **b**) finely ground and kept in a jar or in a bag (shown here).
3 Set squares, 45 degrees and 30/60 degrees. Useful for measuring pen angles and drawing verticals and horizontals.
4 Protractors used for measuring angles or letter slant (italic).
5 "T" square for drawing parallel writing lines.
6 Repositionalable glue stick, non-permanent glue to use for layouts.
7 Pencils (2H, H, and HB).
8 Ruler for measuring and line drawing.
9 Metal straight edge to use when cutting paper.
10 Craft knife for cutting paper.
11 Calligraphy inks, non-waterproof.
12 Scissors.
13 Calligraphy fountain pen with square edge nib. Good for beginner or for practice.
14 Dip pen holders with various nibs. (Rounded barrels are more comfortable.)
a) Osmiroid square edged nib **b**) scroll nibs **c**) mapping nibs **d**) Rexel square edged nibs with separate reservoirs
e) speedball nibs
15 Elbow nib for Copperplate writing.
16 Copperplate nib holder for straight nib.
17 Pen holders.
18 Automatic pens for large-scale writing.
19 Watercolor paint in pans and half pans.
20 Watercolor·paint in tubes for painting and washes.
21 Designer's gouache, opaque watercolor excellent for writing in color.
22 Palette for mixing paint.
23 Brushes, sable or sable/synthetic mix for painting.
24 Pencil sharpener.
25 Eraser
Optional items: dividers for measuring, compass, ruling pen, cutting mat, and sketch book.

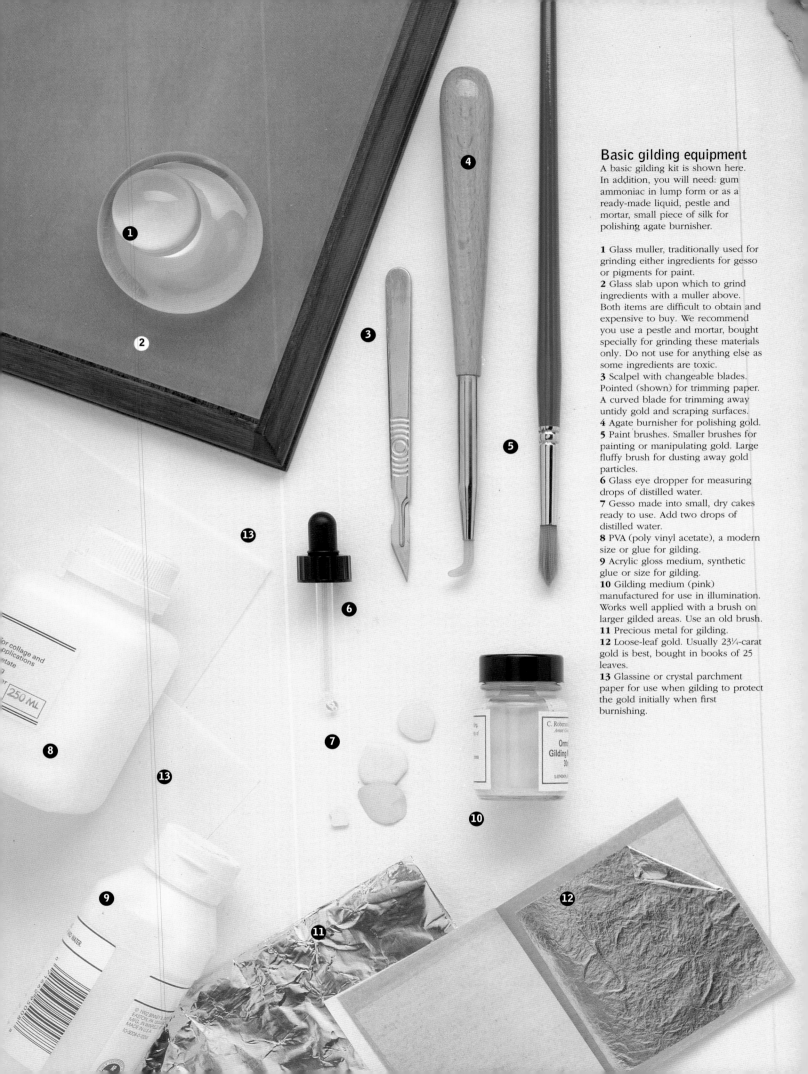

Basic gilding equipment

A basic gilding kit is shown here. In addition, you will need: gum ammoniac in lump form or as a ready-made liquid, pestle and mortar, small piece of silk for polishing agate burnisher.

1 Glass muller, traditionally used for grinding either ingredients for gesso or pigments for paint.
2 Glass slab upon which to grind ingredients with a muller above. Both items are difficult to obtain and expensive to buy. We recommend you use a pestle and mortar, bought specially for grinding these materials only. Do not use for anything else as some ingredients are toxic.
3 Scalpel with changeable blades. Pointed (shown) for trimming paper. A curved blade for trimming away untidy gold and scraping surfaces.
4 Agate burnisher for polishing gold.
5 Paint brushes. Smaller brushes for painting or manipulating gold. Large fluffy brush for dusting away gold particles.
6 Glass eye dropper for measuring drops of distilled water.
7 Gesso made into small, dry cakes ready to use. Add two drops of distilled water.
8 PVA (poly vinyl acetate), a modern size or glue for gilding.
9 Acrylic gloss medium, synthetic glue or size for gilding.
10 Gilding medium (pink) manufactured for use in illumination. Works well applied with a brush on larger gilded areas. Use an old brush.
11 Precious metal for gilding.
12 Loose-leaf gold. Usually 23¼-carat gold is best, bought in books of 25 leaves.
13 Glassine or crystal parchment paper for use when gilding to protect the gold initially when first burnishing.

Choosing papers

There is a vast range of textured, smooth, or colored paper from which to choose. Paperweight is measured in pounds (lbs) or grams per square meter (gsm). The smaller the number, the lighter or thinner the paper will be. The number relates to the weight of a ream or pack of paper, which is 500 sheets. Therefore, 90 lbs (190 gsm) will be thinner than 140 lbs (300 gsm). The surface textures of high-quality watercolor papers are described as hot pressed – smooth surface; Not or cold pressed – slightly textured surface; rough – very textured surface.

Try out your first marks and experiments on different papers and keep notes for future reference. This will help you to learn the individual qualities of each. When buying expensive paper, handle it with care, and where possible, carry it looped rather than rolled or it may become damaged. Store it flat.

Different surfaces

When choosing paper for work, achievable and pleasing effects can be made by using different surfaces.

a) Writing on "hot pressed" (HP) paper produces fine, smooth penwork and is suitable for delicate work.

b) Interesting, slightly textured pen lines are made on "cold pressed" (NOT) paper.

c) An exciting textural feel is produced on "rough" paper, though this is only suitable for use with a larger nib (i.e. automatic pen).

Papers

1 Hand-made papers. These will need to be purchased from specialist shops. There is a good choice of textures and qualities available, depending on the natural fibers used in their manufacture. Their use can add great interest and variety to the written page, and they are delightful as covers for small books and 3-D objects.

2 Machine-made paper. Stocked in most art supply stores. These papers are generally cheaper and made from wood pulp or a mixture of wood pulp and cotton or linen. This paper is made in a long roll and cut into sheets, and is produced in white, cream, and various colors.

3 Layout paper is slightly transparent and has a smooth surface which is most suitable for writing practice. It is used for overlays and paste and cut in designing work.

4 Pastel paper. Good-quality pastel paper is invaluable to the calligrapher. An extensive selection of color, tone, and texture is available, and it usually offers a smooth or a textured reverse side on which to write.

5 Vellum and parchment. Prepared animal skin. Today vellum usually refers to the finer skins such as calf. Parchment is generally sheep skin.

Starting out: the basics

The ideal working conditions for making good calligraphy are: good light, whether daylight or from directed artificial light; a comfortable seat at the right height at a table; a sloped board with a padded writing surface; space to one side for your equipment. Try to arrange to sit so that the available light will not cast any shadows over the area where you are writing.

The drawing board

You need something to lean on, and this should be sloped at about 45 degrees. Writing on a slope is better for your posture and will give the optimum ink flow from the dip pen.

The board's edges should be smooth and straight so that you could use a T-square – avoid putting any tape over the edges.

Pad it with layers of paper for writing comfort – tape carefully all round (but not over the edges). A sheet of paper should be kept as a guard sheet to protect your work, both from splashes and from you: natural oils in your hands can make the paper greasy and difficult to write on.

Position

Prop your board up on the table; either rest it against the edge of the table with the bottom on your lap, or support it with books on the table. If the latter, tape the bottom edge to the table to prevent it from slipping. Check that you are sitting comfortably and that shadows are not cast over the area where you will write. When working on a piece, get up occasionally to stretch your legs and relax neck muscles.

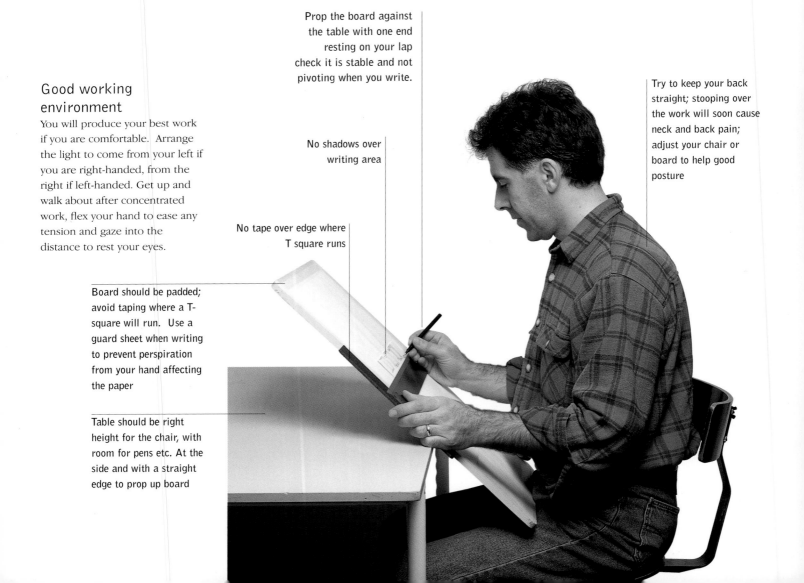

Prop the board against the table with one end resting on your lap check it is stable and not pivoting when you write.

Good working environment

You will produce your best work if you are comfortable. Arrange the light to come from your left if you are right-handed, from the right if left-handed. Get up and walk about after concentrated work, flex your hand to ease any tension and gaze into the distance to rest your eyes.

No shadows over writing area

Try to keep your back straight; stooping over the work will soon cause neck and back pain; adjust your chair or board to help good posture

No tape over edge where T square runs

Board should be padded; avoid taping where a T-square will run. Use a guard sheet when writing to prevent perspiration from your hand affecting the paper

Table should be right height for the chair, with room for pens etc. At the side and with a straight edge to prop up board

Padding the board

1 To pad the board, use two sheets of white blotting paper or several sheets of newspaper with creases ironed out, covered by a sheet of white paper. Cut them to fit the board, allowing room for the tape.

2 Fix the paper down all round the masking tape. Take care not to go over the edge with the tape if you intend to use a T square.

3 The final touch is a narrower sheet fixed across the board with the top edge at writing level. Tape it at the sides and leave the bottom open for your writing paper to be slid up and down.

Starting out –ruling lines

1 Measure accurately how wide apart your lines should be; generally you are measuring "nibwidths".

2 You may prefer to use a pair of dividers if all your lines are to be the same distance apart.

3 Walk the dividers down the side of the page, or mark the measurements with a ruler.

4 When you have marked the measurements on both sides, join the marks with clear sharp lines across with the ruler.

5 If you have a T square, you need only mark down one side of the paper, secure it to the board to prevent it moving, and use the T square held firmly with its edge against the board as you rule lines across.

Making the first marks

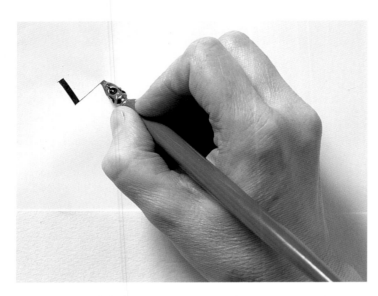

Before you try writing any letters, it is helpful to get to know how a wide nib feels. Unlike a pencil or ballpoint pen, the wide nib makes thick and thin marks, depending on whether you pull it downward or sideways. Care is needed to make sure you are holding the nib firmly and keeping the full width of the nib pressed constantly against the paper:

Left-handers

Twist your wrist a little so you can hold the straight edge of the nib at the required angle; if you have a left oblique nib, you will not need to twist far. You may find it more comfortable to move the paper to the left of your body, but make sure you can still see what you are doing.

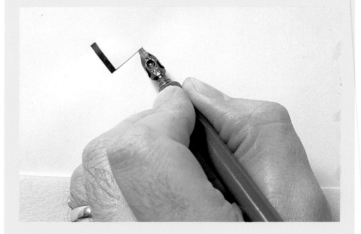

How to hold the pen

Hold the handle close to the nib with your thumb and first two fingers. Twist the handle a little between the fingers until you can feel when the whole width of the nib is in contact with the paper; try a thick stroke, then a sideways thin stroke.

Left-hander "overarm"

If you normally write "overarm," consider writing the letters in a different stroke order, from bottom to top, so you can still pull the ink. Take care not to smudge the writing with your arm.

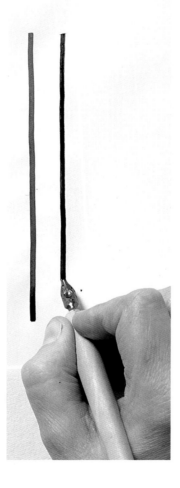

Testing the pen

Dip the pen, check that the reservoir is full, then try making long straight marks the full width of the nib in vertical lines. See how many lines you can make before the ink runs out (see page 22 if the pen won't write).

it will make uneven marks if you tend to skate the nib across or use an unsteady movement.

A good test both of your pen and the steadiness of your hand is to make some long, straight lines using the full width of the nib. If you start with a freshly charged nib, this test will give you a clear indication of the capacity of your pen's reservoir and also give you practice in steady mark making. Keep going until you can make several thick lines without a wobble and without needing to refill. Check that the edges are not ragged; if they are, pay more attention to how you hold the pen; it means one side is not fully pressed onto the paper.

What pen angle?

Writing with a broad-edged pen gives thicks and thins to the letters. One of the features of any script is exactly where those thicks and thins

Ragged and sharp edges

Ragged edges result because there is not enough pressure on the left-hand edge of nib (**1**) or not enough pressure on the right-hand edge of nib (**2**). Sharp edges indicate even pressure of the nib (**3**).

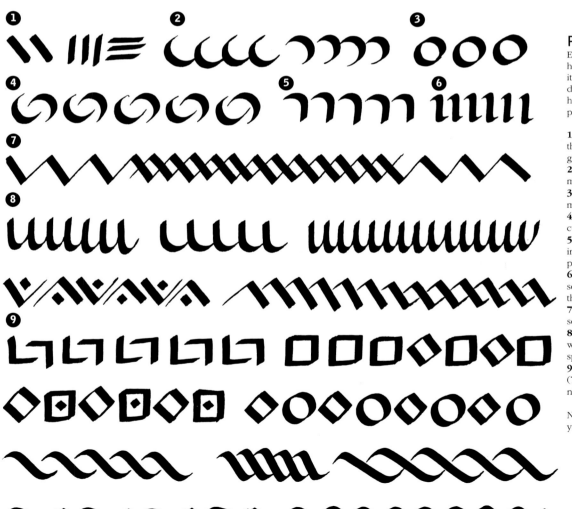

Pen pattern practice

Experimenting with repetitive marks helps you to gain control of the pen; it will also give some ideas for decorative borders! All these marks have been made with a 45 degree pen angle.

1 Straight lines – diagonals give full thickness, verticals and horizontals give thinner.
2 Curves – aim for the crescent moon effect, thin to thick, to thin.
3 Full circle – blend those two movements to make a perfect "O."
4 Linked crescents – overlap the curves for a decorative effect.
5 Curve to straight – start like (2) but incorporate a vertical, don't change pen angle.
6 Vertical – a simple vertical but with serifs for subtlety, made as part of the stroke.
7 Zigzags – start simple and add a second set on top.
8 Vertical to curve – try narrow and wide versions, keep them evenly spaced.
9 Zigzags and diamonds similar to (7) but broken and repeated, with a nibwidth square added.

Now work out how to do the others yourself.

occur; in one style, the thin parts will be at the top and bottom, in another, they will be top left and bottom right. Achieving consistency depends on the angle at which you hold the pen, relative to the writing line. It is essential to practice gaining control of the pen angle so that you are always aware of what angle you are using. Maintaining a constant angle can be harder than it looks. While you are moving your hand to describe the letter shape, there can be a tendency to alter the angle inadvertently, particularly if you are moving your fingers rather than using a wider arm movement.

Practicing pen angles

To help you feel what is happening, try fixing your fingers holding the pen at the desired angle and then using only your arm to make a letter shape. Notice where the thin parts are.

How big to write: "nibwidths"

"Nibwidths" are the guide to how far apart to rule your lines for writing. You will see with every alphabet provided in this book that there is a "ladder" pattern; this is the indication of how many widths of the nib were measured to get the height of those letters.

Getting started

Make vertical marks (with serifs if you can) starting with a flat pen angle and graduating to a vertical one.

Now make this letter t at each of those angles; note how the letter is altered in character because of the weight distribution.

Pen angles (from left) 0°, 15°, 30°, 45°, 60°, 90°.

How pen angle affects letterforms

Look closely at these samples of different styles; notice where the thickest and thinnest strokes are. Contrast the flat pen angle of Uncial with the sharp pen angle of Rustics.

Flat pen angle for this Uncial.

Flat pen angle for Half Uncial.

Pen angle 35 degrees to 45 degrees for Gothic.

Pen angles 15 degrees to 20 degrees for this Uncial.

15 degrees to 20 degrees for Carolingian.

Pen angle 45 degrees for Italic.

Pen angle 30 degrees for Roman Capitals.

Pen angle 30 degrees for Foundational Hand.

Pen angle 30 degrees for Rotunda Gothic.

Pen angle 30 degrees for Batarde.

Pen angle 60 degrees to 80 degrees for Rustic Capitals.

The "ladder" is a set of squares made by the pen at its full width. If you do your own ladder pattern to make the same number of squares, and rule your lines accordingly, your letters should come out with the same weight characteristics as the one you are copying, irrespective of the size of your pen nib.

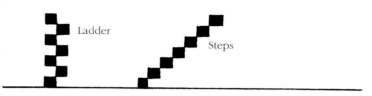

Nibwidths for Copperplate

You can't do them! Copperplate pens are pointed and the thick strokes are made by pressing harder. You have to hold the pen in a different way, too – see below.

Making a ladder and steps

Making a vertical ladder of nibwidths allows you to check you have not overlapped, by putting your pen in the white gap to see if there is room. However, if you find ladders too difficult, make a staircase instead, but double check for overlapping.

Nibwidths: Making a ladder

1 The full width of the nib must be used to mark accurately multiples of the nib's width. You may have to practice this several times to get precise marks. Do several ladders and measure tham all to get an average. Check that you have not overlapped, or left gaps.

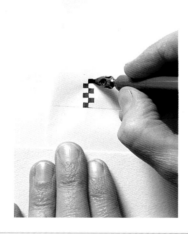

2 Measure carefully with a ruler to the number of nibwidths you know you need for the style you are writing (right), or use a pair of dividers (below).

Holding a copperplate pen

Holding a copperplate pen is quite a different process, as the nib is pointed rather than chiseledged; the thick strokes are made by pressure alone. The nib must be held directly in line with the slope of the writing.

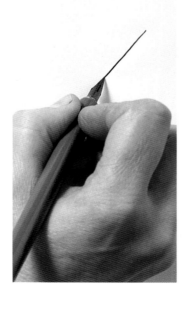

Copperplate for the left-hander

Copperplate may be a more comfortable angle for writing for a left-hander as the pen is not twisted at all.

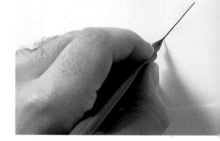

The "elbow" nib

The elbow nib is fashioned to assist the right-hander to twist farther to the right; hold the pen with the handle pointing roughly to your chest.

Getting it right

To produce the crisp, sharp thick and thin strokes that characterize good calligraphy, you need to find a pen, ink, and paper that are all compatible, and practice regularly to get your hand and eye used to making repeated, regular movements.

Most pens will write on a variety of papers with many different inks and paints, but you may encounter some common difficulties.

The pen won't write

● It may have traces of machine oil from manufacture which will resist ink, or it may have a coat of varnish if it is the kind vulnerable to rust; wash it in hot soapy water and try again.

● The ink may be restricted from flowing if the nib has a too-tight slip-on reservoir; gently bend the wings out and slip it back on.

● The reservoir may not be feeding the ink to the slit in the nib: reposition the point of the reservoir so it is in direct contact with the underside of the nib, close to the end.

The pen slips across the paper

● The surface is too smooth, or shiny, or greasy for the pen to get enough grip; change the paper, or rub the surface with gum sandarac (see materials page 12).

● The pen may be blunt; try another nib.

The marks are blobby

● The ink may be too thick; dilute it or change it – check if it is waterproof by trying to smudge it when it is dry, waterproof inks are often rather thick.

● The pen may need to have its reservoir adjusted to feed less ink.

● The pen may be discharging too much ink because you are writing flat; adjust your surface so you are writing on a slope about 45 degrees.

● There may be too much ink all over your nib; shake or wipe off the excess each time you dip.

● The nib may be blunt; try a new nib.

The ink bleeds into the paper

● The paper may not be sufficiently sized to resist ink; change it or try a dusting of gum sandarac which is water-repellent.

● The ink may include chemicals designed to keep it from clogging the pen; these may be encouraging it to seep into the paper. Try a different ink or Designer's Gouache mixed to inky consistency.

Washing the nib

If the ink bubbles off and will not flow down the slit, try washing the nib in hot, soapy water to remove any machine oil or varnish.

Adjusting the reservoir

1 Pull the two side wings apart slightly if the reservoir is too tight – it is made of brass and will not break.

2 Try slipping the reservoir on again, holding it by the wings.

3 The reservoir should be loose enough to slip on and off without force, but not loose enough to fall off and drop into your ink.

4 Take the reservoir off again and check the pointed end; it may have moved out of position following previous maneuvers. Bend it inward.

5 The point will be bent too far over the nib, but this is intentional.

6 As you pull it down onto the nib, the point will be sprung against the underside of the nib so it will stay touching the nib to allow it to feed ink to the slit. Adjust it farther down if the pen discharges too much ink.

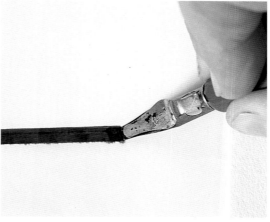

Dusting the paper

Powdered gum sandarac applied to the paper through a porous bag makes the surface more resistant to ink; if it is rubbed rather than dusted, it will roughen the surface slightly which may help if the paper is slippery.

Too much ink

Dipping the pen in ink is potentially a blobby disaster; always wipe the top on the edge of the bottle, or feed the pen with a brush.

Ink bleeding

Some papers are too absorbent for some inks, resulting in ink bleeding into the surface and giving feathery edges.

New nib

Old nib

Compare old and new nibs as shown – nibs wear out and result in a lack of crispness in the writing.

Old nib

Looking at letters

*I*n order to produce beautiful calligraphy, you must first use your eyes. Observe how letters in any alphabet are designed essentially as a matching set. This may be obvious as far as the letter weight and the style of serifs (the ticks or curves or slabs at the ends of letters) are concerned. But you need to look more carefully to notice important details. For example, see how the widths of letters are in proportion, how the capitals generally conform to geometric principles, and how lower-case letters depend on their arch structures to create their overall character.

Capital letters

These were first designed by the Romans 2,000 years ago. Their forms are based on a circle within a square. The most important principle to remember is their relative widths; it might be helpful to memorize these, or at least to copy them in their width groups so as to appreciate how they differ.

Serifs

One feature that affects the character of any alphabet is the kind of endings, called serifs, at the beginning and end of strokes. They are generally hooks or ticks, made as part of the stroke, or thin or thick lines or slabs added as extra strokes. It is an important part of your study to notice what kind have been used in any particular example, and to be consistent when you use them.

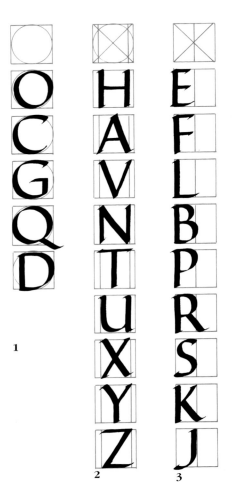

Looking at widths

Roman Capitals showing relative widths.

1 Circular: note how round C, G, and D. are.

2 Wide: approximately ⅘ths of the square.

3 Half width: some protrude at the bottom.

4 M just bursts out of the square, W is much wider.

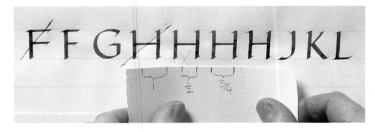

Checking widths

One way to check the width of letters is to use a scrap of paper with the width measurements marked along the edge. Hold it up to the completed letters to get an idea of how you are managing. This will be more helpful in the long term than writing on graph paper, as you may become dependent on the lines and not develop your own judgment.

IF IC DG

DIFFICILE

DIFFICILE

Spacing

Top: Two verticals widest apart, two curves closest.

Center: Word spaced for even texture.

Bottom: Spaced too close, gives dense and light areas.

Lower-case letters; basic hand

"Lower case" is really a term from the days of hand typesetting when the printer kept the minuscule letters in a separate tray underneath the capitals; it has come into common usage as referring to the small letters.

Lower-case letters conform to regular shapes, but in most alphabets there are more letters with curves than there are in the capitals, and they are nearly all the same width. They differ in another way from capitals in having some letters protruding above or below the main writing lines; these are called ascenders and descenders, and help to characterize the letterforms and make them look different from the capitals.

The matching set

The letters in the lower-case alphabet make a matching set by being based on the shape and slope of o and i; in this case, Foundational Hand, based on a circular o and an upright i. Look through some of the lower-case alphabets given in Section 2 (see page 28) and notice how they conform; oval, sloped o's and uprights are common in italic alphabets, for example, and all the letters are narrow and sloped to match.

Arches

Another important feature of any style of lower case alphabet is the way the arches are formed; in an upright, circular one, the arches are joined very high up, with a separate stroke of the pen. By contrast, an italic arch is made quite differently, usually without lifting the pen from the previous downstroke, making it grow out of the first stroke like a branch.

Spacing lower-case letters

As with the capitals, you are looking for even balance between and within letters; some lower-case letters can cause awkward combinations and may need to be squeezed closely together to even out the spaces. Turning the page upside down can help you to spot open spaces and dense areas.

Foundational Hand lower-case letters

Lower-case (minuscule) letters follow the profile of their o, note even on the bottom of t, l. j; diagonals follow its width.

Arches

Contrast the arches between Foundational and Italic; no penlift for Italic (near right), high join for Foundational (far right).

Serifs on lower-case letters

(*left to right*) Rounded serifs complement the rounded letterform; wedged serifs make a more formal effect; round serifs, flat feet make a static, formal effect.

Combinations

Awkward combinations can share a crossbar or be tucked close together to minimize spacing problems

Even spacing

Aim for an even density just as in the capitals. *Top:* evenly spaced. *Bottom:* unevenly spaced.

uvw

cbijklm

lm

Script identifier

How to use the script identifier

The alphabets which follow offer an enormous range of styles. If you flick through the pages

you will see that there is an alphabet for just about every occasion; some are more

complicated than others and need both skill and experience with the pen.

Following the nibwidth rule

Same alphabet, different size of nib; scaling up or down is easy as long as you keep strictly to the number of nibwidths shown for each alphabet.

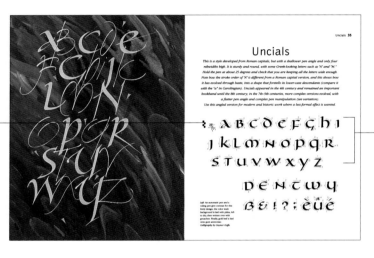

The main alphabet shown has directional arrows to help you begin, with explanation of what you need to know. These main alphabets are arranged in the book in the order that they evolved historically.

The variations

These variations are smaller, in order to fit them all in, but you should first learn to write them with a pen the same size as for the main alphabet. No directional arrows are provided. This is because you shouldn't need them once you are familiar with the main version (don't try them until you are!).

The alphabets are divided into 10 sets, each set starting with an exciting alphabetical design related to the scripts covered.

Look closely at the overlay of the letters "AHOP / ahop." They are to help you compare the variation with its parent alphabet.

With lower case, this "ahop" shows an ascender and descender, an arched letter, and the "o" which governs the width and shape of the others. For capitals, this "AHOP" gives a selection of width letters, including the all-important "O," plus diagonals, curves, uprights, and a cross-bar.

The pages of variations are illustrated with a textural area to give an indication of how they will look in a block of writing. The caption highlights major points.

Each variation includes pen angle diagrams and an overlay of some letters to indicate how this version differs from the main alphabet.

If the control and the variation are very similar you won't notice much difference between the red and the black letters.

If the control and the variation are very different, there is a considerable difference in the widths the two alphabets make.

Begin with a basic style, Foundational is recommended, though some people prefer to start with italic if that is closer to their normal handwriting.

Choose one of the main alphabets (one which has arrows), and study it carefully. Read the instructions and take note of any special features that are mentioned, most importantly, the number of nibwidths and the pen angle. Other characteristics to spot are:

Is it upright or sloped?

Is it round, or oval, or squashed close?

How prominent are any ascenders and descenders?

Are the arches of lower case letters joined high up or low down?

What are the serifs like?

Copy the alphabet carefully, at the correct height and pen angle, following the directional arrows. Move on to another letter after three or four tries, do not get stuck on one letter, it is likely to get worse, not better!

When you are familiar with the formation of the letters in your chosen alphabet, write words and sentences to discover any awkward combinations. When you are fully confident of writing that alphabet in the large size, you can try smaller pens; remember to check your nibwidths carefully.

You can never get enough practice! This is the best way to get a good rhythm, once you have the letterforms clear; write the same phrase over and over, or write a sequence of letters such as anbncndn, or a familiar, long quotation. The more you write, the more confident and even your writing will become.

Have fun selecting the alphabet to suit your needs; when you have chosen, take time to study its subtleties, and practice frequently and critically, until your copy looks like the example. There are a hundred to choose from, but take care not to rush through and get confused. This is a lifetime's supply!

Ruling lines

All the alphabets provided give an indication of how many nibwidths high to allow when ruling lines. Then you need to know how far apart each set of tramlines should be when writing more than one line. The following diagram explains how.

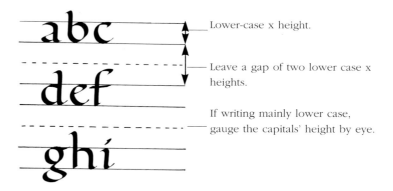

Lower-case x height.

Leave a gap of two lower case x heights.

If writing mainly lower case, gauge the capitals' height by eye.

Capitals x height.

Leave a single gap between lines of capitals.

Add another line if there will be some lower case letters.

Spacing between lines

Standard interline spacing; use for text where most will be in lower case (minuscules) with occasional capitals.

Reduced interline spacing, one lower case x height apart; makes a dense texture. Best for stacked single words, more would be hard to read.

Increased interline spacing: makes a lighter texture but beware as lines of text can appear to float away.

Roman Capitals

The structure of Roman Capitals is geometric, based mainly on squares and circles. Hold the pen at 30 degrees from the horizontal; if you have got it right, T should have a thinner horizontal stroke compared with its vertical, and O should have its thinnest parts at 11 and 5 o' clock. The exceptions are: flatten the pen to get a thicker diagonal on Z; steepen the pen to get a thinner stroke for the first vertical of M and first and last of N. Capital have survived relatively unchanged for 2,000 years, and are still perfect for important titles, headings and signs, by themselves or combined with other hands.

ABCDEFG

HIJKLMNOP

QRSTUVW

XYZ &!?; ĚÜÉ

1234567890

(Left) Carefully proportioned Roman Capitals are overlaid to show their geometric relationships; these provide a contrast to the three more freely written alphabets on textured paper. Note the visual interest of heavyweight heavyweight lettering against a similarly sized alphabet of more standard weight, while the tiny letters give a change of scale.

Roman Capitals

DIFFICILE EST VERUM HOC C

Renaissance A lighter weight version of eight nibwidths, with thin serifs and some Renaissance styling – note Y formation, top lead-in serifs on B, F, R.

ABCDEFGHIJKLMN
OPQRSTUVWXYZ
&!?;ÈŨÉ 30° 15° AHOP

DIFFICILE EST, VERUM HOC

Heavyweight More freely written, at only five nibwidths. Make sure you do not sacrifice good letterforms when attempting to loosen up in this way.

ABCDEFGHIJKLMN
OPQRSTUVWXYZ
&!?;ÈŨÉ 30° AHOP

DIFFICILE

Sloped standard Seven nibwidths height but this version is sloped; not to be confused with an italic, which would be compressed in width.

ABCDEFGHIJKLMN
OPQRSTUVWXYZ
ß&!?;ÈŨÉ 30° AHOP

DIFFICILE EST T, VERUM HO

Heavy and chunky Five nibwidths with slab serifs; the serifs at the ends of examples C and E are made of downward strokes still at 30 degrees.

ABCDEFGHIJKLMN
OPQRSTUVWXYZ
&!?; ÈŨÉ 30° AHOP

UM HOC QUA LUB LUBET EFFICIAS·D CIAS·DIFFICILE EST

Lightweight This lightweight style can show up any hesitation. Use a small nib, and take care how you blend the joins between strokes.

ABCDEFGHIJKLMN
OPQRSTUVWXYZ
&!?;ÈŨÉ 0° 30° AHOP

ABCDEFGHIJKLMN
OPQRSTUVWXYZ
ß&!?;ÈÜÉ 30° AHOP

DIFFICILE EST

Sans serif No serifs on this one, but standard seven nibwidths; instead of serifs, apply subtle pressure at the beginning and end of strokes.

ABCDEFGHIJKLMNOPQRST
VVWXYZ&!?;ÈÜÉ 70° AHOP

DIFFICILE EST, VERUM
RUM HOC QUALVBET

Rustics Thick horizontals and thin verticals characterize this style; all horizontals slope downhill, and bottom serifs look as if they are on tiptoes.

A B C D E F G H I J K L M N
O P Q R S T U V W X Y Z
ß & ?!; É Ű È 30° AHOPP

DIFFICILE EST
VERUM HOC

Pressure and release You need some experience to do this version justice as its beauty is in its subtleties. Press at beginning and end of strokes.

ABCDEFGHIJKLMN
OPQRSTUVWXYZ
&!?;ÈÜÉ 0° 90° AHOP

DIFFICILE EST, V
RUM HOC QUA

Neuland This heavyweight style uses thick strokes only, which means holding the pen vertically and horizontally to avoid any thins.

ABCDEFGHIJKLM
NOPQRSTUVWXYZ
ß&!?;ÈÜÉ 10° 30° AHOP

DIFFICILE
EST, VERUM

Flourished Nine nibwidths gives this style a lightness needed to complement the flowing extensions. Make the sweeping strokes as part of the letter.

Uncials

This is a style developed from Roman capitals, but with a shallower pen angle and only four nibwidths high. It is sturdy and round, with some Greek-looking letters such as "A" and "M." Hold the pen at about 25 degrees and check that you are keeping all the letters wide enough. Note how the stroke order of "A" is different from a Roman capital version, and this shows how it has evolved through haste, into a shape that foretells its lower-case descendants (compare it with the "a" in Carolingian). Uncials appeared in the 4th century and remained an important bookhand until the 8th century; in the 7th–9th centuries, more complex versions evolved, with a flatter pen angle and complex pen manipulation (see variation).

Use this angled version for modern and historic work where a less formal effect is wanted.

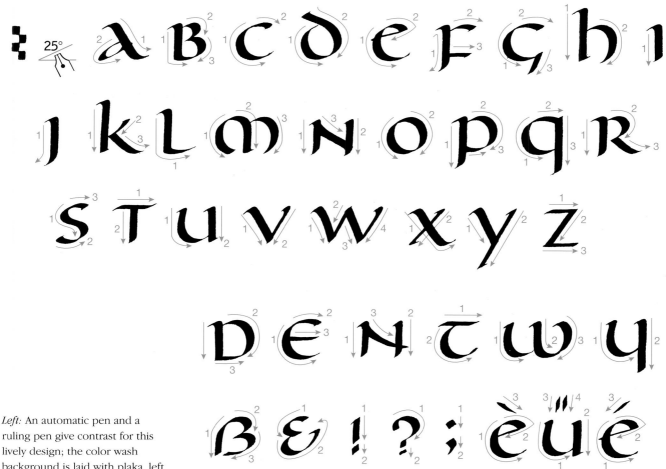

Left: An automatic pen and a ruling pen give contrast for this lively design; the color wash background is laid with plaka, left to dry, then written over with gouaches. Finally, gold leaf is laid onto gum ammoniac.
Calligraphy by Gaynor Goffe.

ficile est verum
qua lubet efficias

Lightweight, compressed This
variation is a freer, oval interpretation
at six nibwidths and at a comfortable
30 degrees; note the forward slope.

ABCDEFGHIJKLMNOPQR
STUVWXYZ
ß &! ? : è ű é

30°

ahop

ficile est verum hoc
a lubet efficias diffi
le est verum hoc qua

Heavyweight Only two and a half
nibwidths high makes this very dense;
it is upright with open, rounded
shapes and shallow pen angle.

ABCDEFGHIJKLMN
OPQRSTUVWXYZ
ß &! ? ; è ű é

25°

ahop

ficile est verum
qua lubet efficias
ficile est verum

Lightweight, free Try this one when
you have complete fluency in the
hand, as it needs to be written with
speed, but take care to retain the
letterforms.

XBCDEFGHIJKLMN
OPQRSTUVWXYZ
ß &! ? ; è ű é

25°

ahop

ficile est verum hoc qua
bet efficias difficile est
rum hoc qua lubet efficias

Standard, compressed Four
nibwidths but more oval than the
standard and with a slight forward
slope; note the "e" ligature.

ABCDEFGHIJKLMNOP
QRSTUVWXYZ
ß &! ?: è ű é

30°

ahop

ıABCDEFGhıJKLMN
OPQRSTUVWXYZ
ß&!?;èűé

25°

ahopp

difficile est verum
hoc qua lubet effici
difficile est verum

Very lightweight Twelve nibwidths of a thin pen gives an outline appearance; try not to get wobbles! Keep it upright and rounded.

˙ABCDEFGhıJKLMN
OPQRSTUVWXYZ
ß&!?;èűé

25°

ahopp

difficile est veru
hoc qua lubet eff
difficile est veru

Expanded Only three nibwidths high but spread out laterally, which makes it look more lightweight and slightly sloped – try writing at speed.

ABCDEFGhıJKLMNOPQRSTU
VWXYZ
ß&!?;èűé

35°

ahopp

difficile est verum ho
qua lubet efficias dif
cile est verum hoc qu

Very compressed Looks much denser than above even though it has more nibwidths, owing to the tight lateral compression; slightly sloped.

˙ABCDEFGhıJKLMN
NOPQRSTUVWXYZ
ß&!?:èűé

0°

ahop

lubet officias diff
est verum hoc qua
officias difficile e

Square A more ancient look with a completely flat pen angle; serifs on "C," "E," "F," etc., are made by twisting the pen onto one edge, much heavier because of the tight compression.

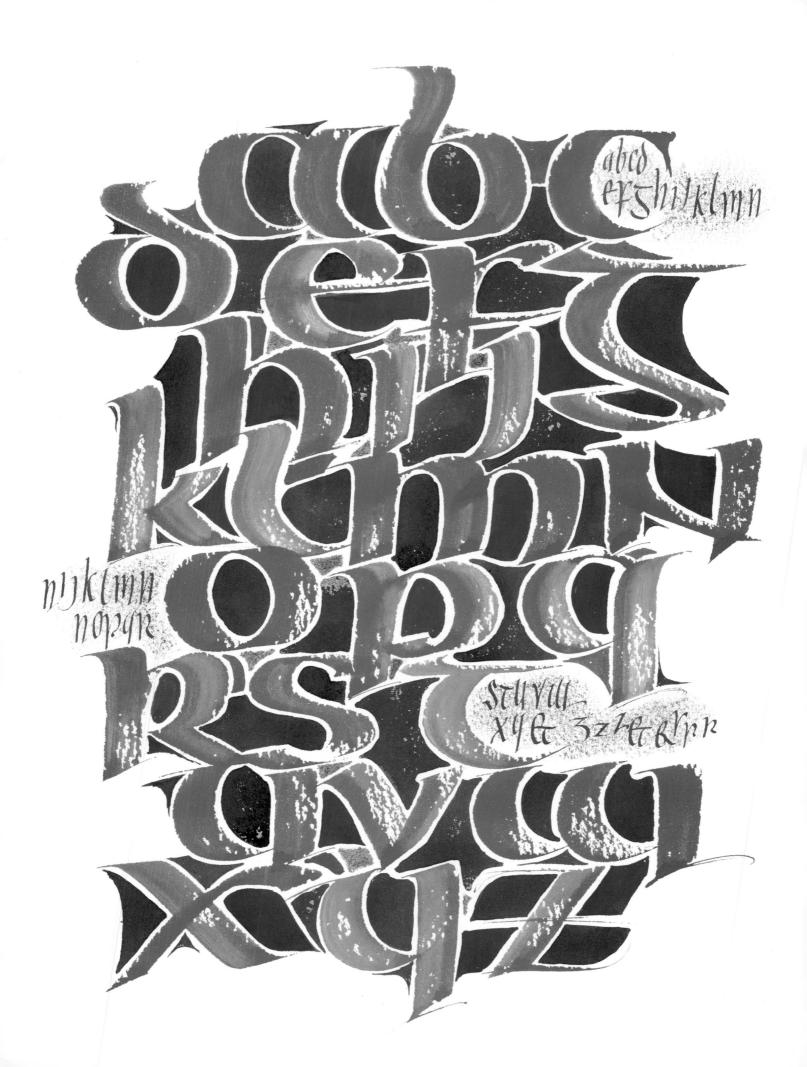

Half Uncials

This is a very rounded, curvy alphabet which stands on its own as a complete alphabet. Hold the pen very flat (only 5-15 degrees) to make thick verticals and thin tops and bottoms of curved letters. The wedge-shaped serifs add weight to compensate for that thinness; make them as a separate curved stroke and blend carefully into the stem. Keep the ascenders, where there are any, shallow.

This style evolved alongside uncials between the 7th and 11th century, some versions having quite pronounced ascenders and descenders, showing the first sign of a lower-case development. Use this hand by itself, or with versals or Roman capitals, for formal or informal occasions; especially suited to early Christian texts.

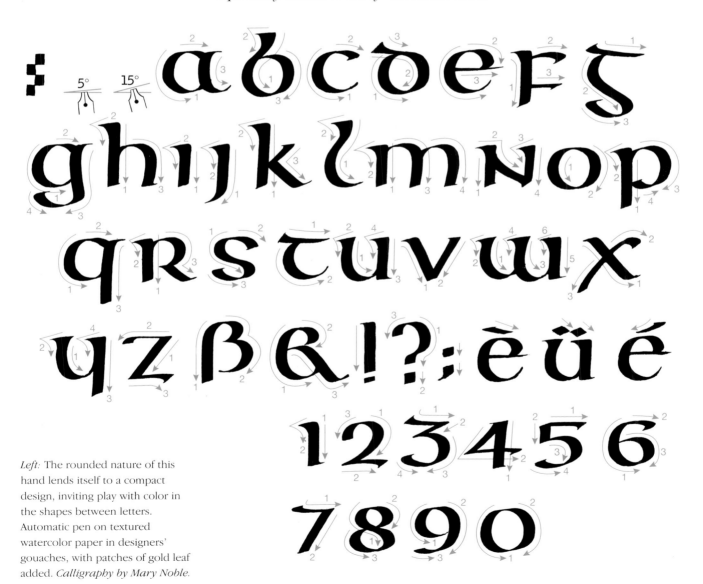

Left: The rounded nature of this hand lends itself to a compact design, inviting play with color in the shapes between letters. Automatic pen on textured watercolor paper in designers' gouaches, with patches of gold leaf added. *Calligraphy by Mary Noble.*

fficile est verum t
oc qua lubet effic

No wedges A freer version with a more comfortable pen angle and curved serifs. Notice how the curve on "H," "M," "R," and "P" branches from the main stem.

:abcdefghijklmn
opqrstuvuuxyyz
ßߡ!?;ĕüé

20° ahop

Fngnhninjnknlnmnonpnqnrn
nunvnwnxnynznanbncdnenfngnj

Compressed, tall Anglo-Saxon style looks more lower case. Make main strokes at 5 degrees, but twist the pen for the thin branching joints.

iabcdefgghijklmnopqr
stuvwxyz ßߡ

50° 60° ahop

nbncnpndnene
pnfngnhninjn

Anglo-Saxon In another form, with soft wedges on some serifs. Two "R"s are shown, the third "r" is actually an ancient form of "S"!

:abcdeefghijklmno
pqrrrstuv wxyz ßߡ
!?;ĕüé

30° 40° 60° ahop

fficile est veru
hoc qua lubet

Expanded, sloping Still four nibwidths but spread out makes informal effect. Make branching arches on "H," "K," "M," "P", and "R" with no penlifts.

:abcdefghijklm
nopqrstuvuux
yzßߡ

20° ahop

:abcdefgghijklm
nopqrstuvwxyz
ßℜ!?;ĕŭé

5° ahop

efficias·difficile e:
verum hoc qua l

Shallow, heavyweight At three
nibwidths and with the wedge serifs.
The wedges of "D" and "T" require
some pen manipulation.

:abcdefgghijklm
nopqrstuvwxyyz
ßℜ!?;ĕŭé

20° ahop

difficile est verum h
qua lubet efficias ·

Lightweight Six nibwidths and with
curved serifs, and high branching
arches. Keep the letters open and
matching in widths.

:abcddefghijklm
nopqrstuvwxyz
ßℜ!?;ĕŭé

15° ahop

anbcededfeʒehr
okelmneoprese

Oval At five nibwidths, slightly
compressed into an elegant oval;
wedges understated – blend them in
smoothly; keep pen at a consistent
15 degrees.

:abcdefghijklmnopq
rstuvwxyzßℜ!?;ĕŭé

30° ahop

abecdefʒegehijeklem
peqresteuevwexyeza

Compressed, sloped Same weight as
above, but more compressed and with
a definite slope. Note the rounded
high branches on "H," "K," "M," "P,"
and "R."

Versals

In both historical and modern forms versals are made with compound pen strokes. Three strokes of the pen held horizontally (0 degrees) make the letter stem. Curved areas are made of three strokes, but with the pen held at a slight angle. The stems are slightly "waisted" for elegance. The letter structures closely follow the classical Roman capitals. On heavier forms the letters can be outlined with the pen and painted with color. The finest examples of versals are in 9th–10th century manuscripts, used as headings or to denote beginnings of verses, usually in red or blue. Today they can be used as complete text.

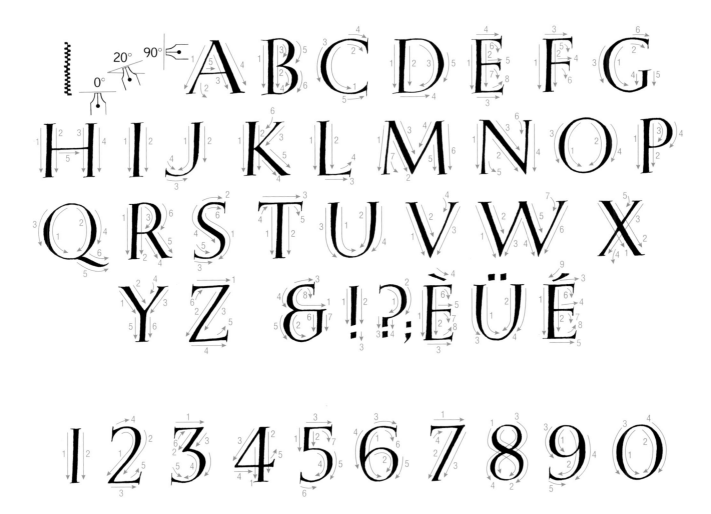

Left: These elegant letters were pen drawn in red and yellow gouache, on a background wash of colored acrylic ink which gives a sealed surface on which to write. Diamonds are gold transfer on raised PVA (white craft). *Calligraphy by Janet Mehigan.*

FFICILE EST VERUM HOC
A LUBET EFFICIAS DOCIL
EST VERUM HOC QUA LUB

Lightweight, compressed Draw
with three pen strokes of a small nib at
twenty-four nibwidths height. Hairline
serifs. Note the compressed shape of
"D," "C," "G," "O," and "Q."

ABCDEFGHIJKLMNO
PQRSTUVWXYZ
&!?,ËÜE

AHOP P

LUBET EFFICIA
DIFFICILE EST V

Sans serif No serifs on this example
give a modern look. Construct stems
with slightly curving outer strokes and
infill with the third pen stroke.

ABCDEFGHIJKLM
NOPQRSTUVWXYZ
&!?,ÈUE

AHOP

ILE EST VERUM
QUA LUBET OF
S DIFFICILE ES

Lombardic Based on a 12th-century
versal. Beginning of decorative letters
and used singly. Draw with a small nib
and "flood-in" letter shape with color.

ABCDEFGHIJK
LMNOPQRSTUV
WXYZ&!?,ÊÜÊ

AHOP

FFICILE ESTV
RUM HOC QU

Skeleton versals Draw with a small
pen, twenty-four nibwidths letter
height. Use only two strokes for
downward stems and letter curves.

ABCDEFGHIJKLM
OPQRSTUVWXYZ
&!?,ÈÜÉ

AHOP

ABCDEFGHIJKLMN
OPQRSTUVWXYZ
&! ?, ÈÜÉ

0° 20° 90°

AHOPP

DIFFICILE EST VE
UM HOC QUA LU

Sloped versal (italic) Slightly compressed with an upward lift. Often drawn with lateral movement, making it appear to dance on the page.

ABCDEFGHIJKLMN
OPQRSTUVWXYZ
& !?, ÈÜÉ

0° 20° 90°

AHOP

DIFFICILE EST V
RUM HOC QU

Sloped sans serif No serifs on this one but slightly weighted at tops and bottoms. Looks modern and elegant.

ABCDEFGHIJKLM
NOPQRSTUVWXYZ
&! ?, ÈÜÉ

0° 20° 90°

AHOP

DIFFICILE EST
ERUM HOC QU

Decorative Small pen twenty-four nibwidths high. Very thin strokes with exaggerated shapes on curves. Extended curved serifs. Draw freely and sloping.

ABCDEFGHIJKLM
NOPQRSTUVWXYZ
&!?,ÈÜÉ

0° 20° 90°

AHOP

DIFFICILE EST V
RUM HOC QU

Modern Slanted and slightly curved upright strokes. Note the slanted 20-degree serifs and their individual formation.

ALPHABET ALPHABET

ABCDEFGHIJKLMNOPQRSTUVWXYZ
abcdefghijklmnopqrstuvwxyz

abc

alphabetalphabetalphabetalphabet

xyz

abcdefghijklmnopqrstuvwxyz
ABCDEFGHIJKLMNOPQRSTUVWXYZ

ALPHABET ALPHABET

Carolingian

A rounded letter based on an extended "o" shape, written at a constant 30-degree pen angle. The interlinear space is large (almost three times x-height of letter), giving an open, flowing letterform across the page. Original manuscripts were written with uncial and/or versals. The modern capitals here are sloped Roman capitals written at six nibwidths height. Note the springing arches at the top of "B," "D," "P," and "R" to relate with miniscule arches. Carolingian was a 9th-10th century standard bookhand, pleasant to read, that evolved in the court of King Charlemagne. Used as a bookhand today.

Left: A simple, alphabetic design with the emphasis on letter and color harmony. Written in gouache on black, pastel paper. The capitals top and bottom are gold gouache to create contrast. *Calligraphy by Janet Mehigan.*

bncndnenfngnhninjknl monpnqnrrsntnunvnwn

Carolingian bookhand Early 9th century miniscule. Pen angle 30 degrees three nibwidths x-height, sloped. "Club" terminals of the ascenders perhaps made by an upward, then downward, movement on the stroke.

abcdefghijklmnop rstuvwxyz ß&!?;ēüé

30°

ahop

bncndnefnghninjnkl nonpnqnrrsntnuvnwn

Tall and elegant Rounded miniscules have ascenders and descenders twice the x-height with large, wedged serifs. Line spacing gives a spacious, elongated look. High arches.

abcdefghijklmnopq rstuvwxyz ß&!?ēüé

30°

ahop

bncndnenfngnhninjnknl npnqnrrsntnunvnwnxny anbncndnenfngnhninjkn

Modern formal Small, hook serifs. Ascenders and descenders same nibwidth height as x-height (3:3). Rounded, similar to foundational but with springing arches.

abcdefghijklmnop qrstuvwxyz ß!?;ēüé

30°

ahop

bncndnenfngnhninjknlnmn pnqnrsntnunvnwnxnynynz ncndnenfngnhninjknlnmn

Shallow, slab serifs Write at three nibwidths with a flattened pen angle of 20 degrees to create a "chunky" look. Gives a strong linear quality across the page.

abcdefghijklmnop qrstuvwxyz ß&!?ēüé

20°

ahop

: abcdefghijklmnopqr
stuvwxyz ß&!?; ēüé

30° ahop

anbncdnenfngnhninjnknln
nonpnpnqnrnsntnunvnwnxny

Lightweight with "club" serif Write
with a small nib. Based on an extended
"o." Gives a delicate, open feel with an
emphasis on the heavier ascenders.

↗ abcdefghijklmnopq
rstuvwxyz ß!?;ēüé&

30° ahop

anbncdnenfngnhninjnknl
nmnonpnqnrsntnunvnwnx
ynznanbncdnenfngnhinjn
nlmnmonpnqnrsntnunv

Heavyweight Two and a half
nibwidths with small serifs. Note the
slight inward pull on the last strokes of
"h," "m," and "n." Be watchful of good
inside letter shapes (counters).

: abcdefghijklmn
oprstuvwxyz ß!?
;ēüé

30° ahop

anbncndnenfngr
ninjnknlmnonpr
rnsntnunvnwnxnyn

Expanded Based on an extended "o."
Wide, with low springing arches and
generous serifs.

: abcdefghijklmn
opqrstuvwxyz
ß&!?;ēüé

30° ahop

anbncdnenfngnhinjnk
nlmnonpnqnrnsntnunv
wnxnynznanbncdnenf

Expanded: flourished More freely
written version of the above. Three
nibwidth x-height. Wide, open letters,
flowing descenders, generous serifs;
creating vitality within the letterform.

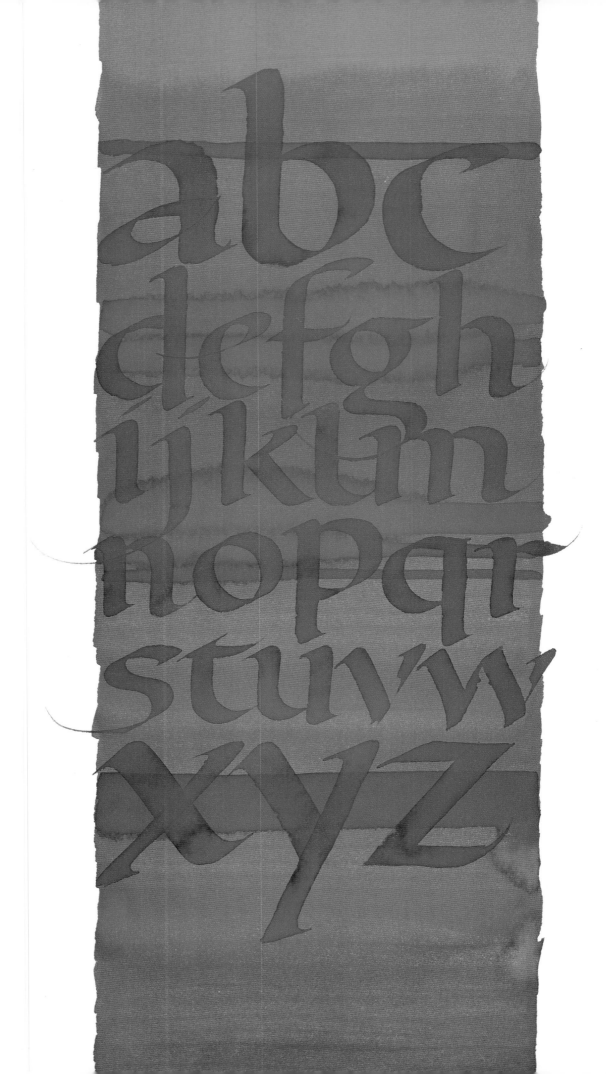

Foundational

Foundational hand was devised by Edward Johnston (1872-1944), based on his studies of 9th and 10th century manuscripts, in particular the Ramsey Psalter (Harley Ms 2904), *a Carolingian script. The modern foundational hand is slightly different from the original manuscript. Calligraphers today have imposed rules to allow the script to be consistent. Written upright at four nibwidths x-height, at a constant pen angle of 30 degrees (except diagonals), the letters are formed with frequent penlifts, beginning and ending with small serifs. This gives the script its formal characteristics. We use classical Roman capitals with this script. In the 10th century, the capitals would have been uncial or versals.*

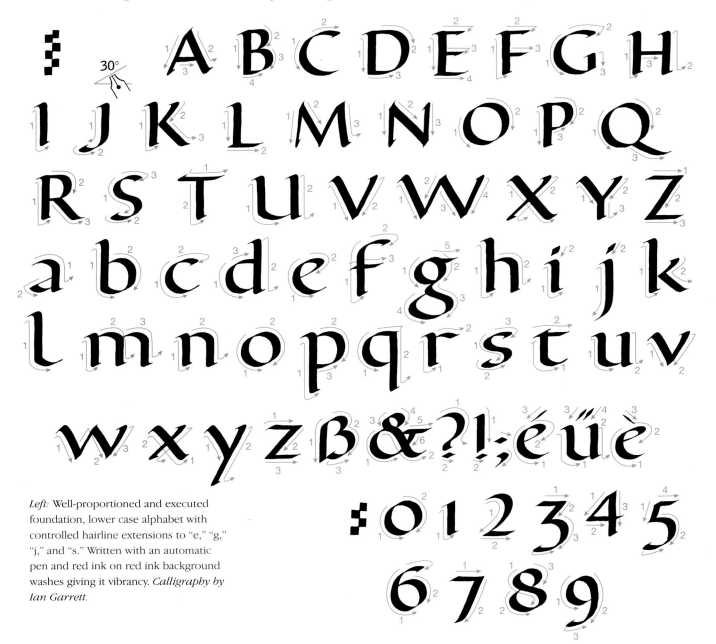

Left: Well-proportioned and executed foundation, lower case alphabet with controlled hairline extensions to "e," "g," "j," and "s." Written with an automatic pen and red ink on red ink background washes giving it vibrancy. *Calligraphy by Ian Garrett.*

anbncndne ngnhnínjn

Heavyweight Write at three nib-widths x-height with wedge serifs for a slightly stronger look. Note the high, firm arches of "h," "m," and "n."

ʒabcdefghijklmno
pqrstuvwxyz ß & ?!;
éűè

30° 45° ahop

anbncndnenfn gnhnínjnknln

Lightweight Five nibwidths x-height and slab serifs throughout give this variation elegance rather than strength.

ʒabcdefghijklmn
opqrstuvwxyzß
&?!;éűè

30° 45° ahop

anbncndn ngnhnínj

Heavyweight Only two nibwidths x-height, with letters stretched laterally to preserve internal spaces. Slab serifs. This gives the letterform a very strong texture.

ʒabcdefghijklm
nopqrstuvwxy
zßɋ?!;éűè

20° 45° ahop

anbncndnenfngn nínjnknlmnon

Compressed Based on an almost straight-sided "o," this script has a rhythm of emphasized verticals. Small serifs. Note pen angle changes.

ʒabcdefghijklmnop
qrstuvwxyz ß&?!;éűè

35° 50° ahop

ʇabcdefghijklmnop
qrstuvwxyz ß&?!;
éűè

20° 45° **ahop**

anbncndnenfng
hninjknlnmn

Compressed, slanting Rounded
arches and a flattish pen angle of 20
degrees characteristic of foundational.
Steeper angle refers to first strokes of
"v," "w," "x," and "y."

ʇabcdefghijklmnop
qrstuvwxyzß&?!:éűè

30° **ahop**

anbncndnenfn
gnhninjnknlr

Cnut charter Compressed sloping
letters, springing arches and pen
manipulation on many strokes. Based
on an early 11th century manuscript.
Note inward pull on "u," "h," "m," "n."

ʇa b c d e f g h i j g j k k l m n o p
q r s t u v w x y z ß&??!;éűè

25° **ahop**

anbncndnenfngnh
injnkNnlmnopn

Heavy compressed Strong
compression and a flattish pen angle
(25 degrees), give this variation a
dense texture. Note the use of wide,
low capitals to break the pattern.

ʇabcdefghijklmn
opqrstuvwxyzß
&?!;éűè

35° ahop

anbncndnenf
gnhninjnknlr

Informal and freely written A
variation at four nibwidths.
Manipulated pen angles. Hairline serifs,
several ligatures, and movement
(dancing), in the lines of writing.

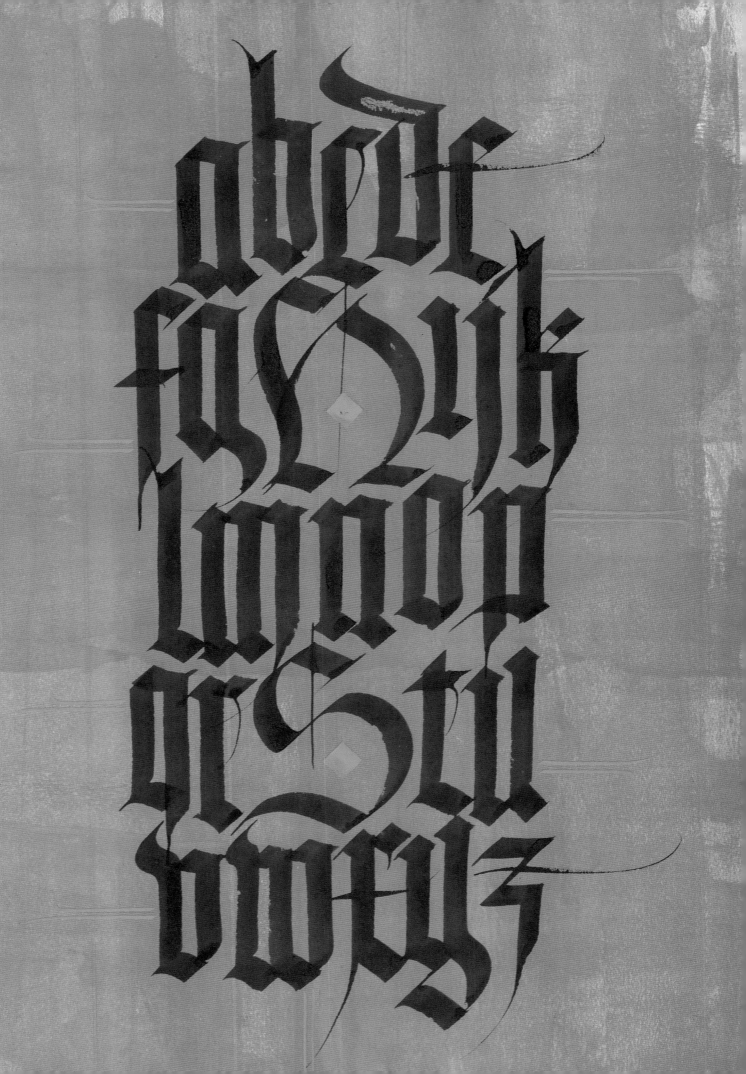

Gothic

Gothic has dense, angular strokes and diamond heads and feet. Written generally at four to five nibwidths x-height, with narrow counters (one to one and a half nibwidths), it is very textural and difficult to read. The pen is held at 40–45 degrees, and letters are created with many penlifts and manipulated angles.

The capitals, unlike the lower case, are wider and rounder in shape, with the addition of elaborate hairline structures and flattened diamond shapes for decoration, which creates great contrast. In Gothic manuscripts, versals were often used for capitals.

This style evolved from the Caroline miniscule, and by the 13th century, it was well established as a prestigious bookhand, continuing in its many forms until the 16th century.

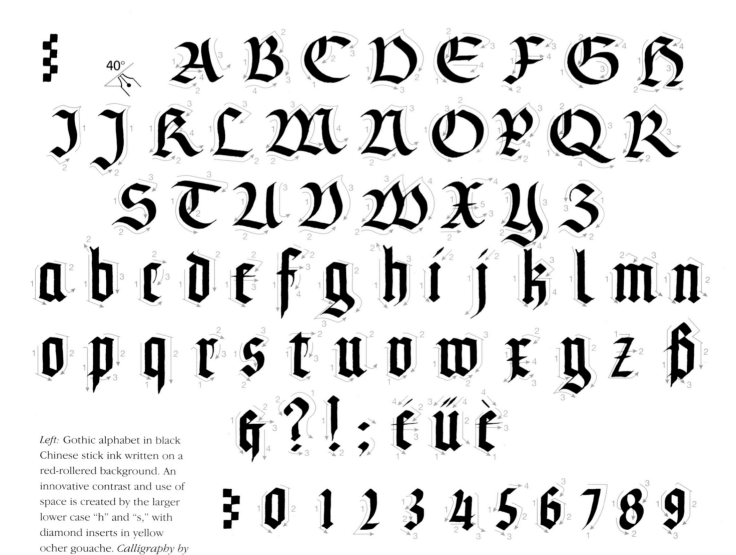

Left: Gothic alphabet in black Chinese stick ink written on a red-rollered background. An innovative contrast and use of space is created by the larger lower case "h" and "s," with diamond inserts in yellow ocher gouache. *Calligraphy by Ian Garrett.*

nbncnonenfngn
hnijknonlomno

Rotunda This rounded letterform is based on a 15th-century Italian style. This less angular, more open Gothic style is very legible. Note the various pen angles.

;abcdefghijklmn
opqrstuvwxyz3
ß&!?;ëüé

0° 20° 30°

ahop

knlnmonpnqn
nunvuwnxnynzn

Rotunda capitals Nibwidths of five for lowercase, and seven for capitals, makes this a lighter-weight letterform than above. Write fairly freely.

;ABCDEFGHIJKL
MNOPQRSTUVW
XYZ ;abcdefghijklmnop
qrstuvwxyz3ß&

10° 40°

ahop

bncnonefngnhinijnknmmonpnq
pnqnrsntunvnwnxnynznanbn
dncfngn hninjn kn lmmmnopnqmr

Textura prescissus Use a 45-degree pen angle. Very textural and slow to write. Note some "feet" of letters are flat. Pen manipulation – flatten pen at base of letter, or fill remaining shape with nib corner.

; abcdefghijklmnopq
rstuvwxyzß&!?;ëüé

 45°

ahop

ncndnenfngnhinjnknln
nonpnqnrnsntnunwnx
nanbncndnenfngnhnin

Modern quadrata From the same historical period (13th century), but less rigid than the letterform above, with "diamond" tops and bottoms. Write at a 45-degree angle and at four nibwidths.

;abcdefghijklmnopq
rstuvwxyz ß&!?;ëüè

45°

ahop

ʒ a b c d e f g h i j k l m n o p q
r s t u v w x y z ß & ?!.;éüè

 40° ahop

anbncndnenf
gnhninjnknlmn

Modern gothic Simplified, but use of pressure at the top of ascender to give definition. Note direction of strokes at tops and bottoms of bowls and arches.

ʒ a b c d e f g h i j k l m n o p q
r s t u v w x y z ß & ?!.;éüè

 40° ahop

anbncndnenfng
nhninjnknlmn

Shaped Written at five nibwidths x-height. A variation with many concave vertical strokes to produce a more dancing texture.

ʒ a b c d e f g h i i j k l m n o p q
r s t u v w x y z ß & ?!.;éüè

40° ahop

anbncndnenfn

Contemporary Fractured letterform written at six nibwidths x-height. Lightweight with many curved strokes creating exciting text. Can be used as a display script.

ʒ a b c d e f g h i j k l m n o p q r s t
u v w x y z ß & ?!.;éüè

 50° ahop

anbncndncafqnn
nknlnmnonpnharr
taunvnwarnynznß

Squat Based on Rudolf Koch. Mix of angles, and curves, and verticals which break part of the way up, producing a lively texture in this densely written variation.

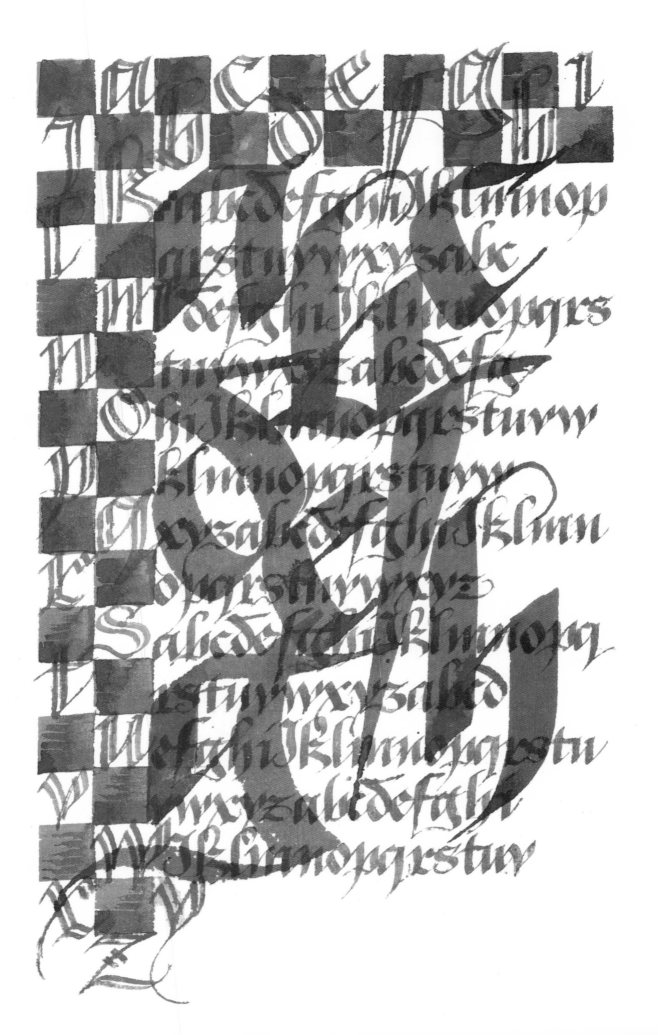

Bâtarde

This is a Gothic cursive hand, a more freely written, everyday style than the formal Gothic hands of the previous pages. Several versions of some letters are given copied faithfully from French manuscripts of the 13th–16th century. The lower case is only three nibwidths high, and has sharply pointed arches and quite a lot of pen twisting. Some strokes may be difficult with a modern nib as they were invented for the more flexible quill pen. Drag the ink along the corner of the nib to make the hairline strokes; twist the pen on the downward stroke of "F" and "p" to get the tapering point. The capitals tend to vary a lot in height.

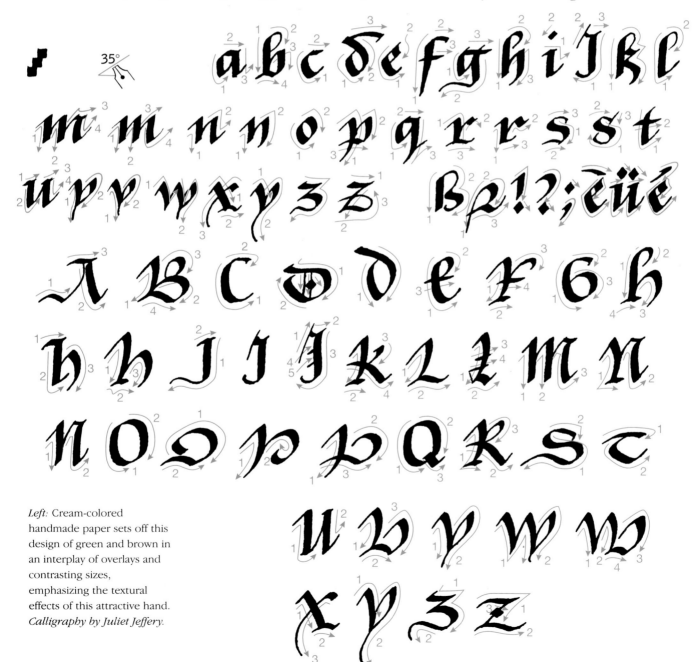

Left: Cream-colored handmade paper sets off this design of green and brown in an interplay of overlays and contrasting sizes, emphasizing the textural effects of this attractive hand. *Calligraphy by Juliet Jeffery.*

ubncndnenfng jnhninjnknln

Simplified Not so much detail as the main alphabet; the main pen angle is about 37 degrees, but you need to twist the pen to get the hairlines.

ɼ a b c d e f g h i j k l m n o p q r s t u v w x y z ß ꝛ ! ? ; ē ü é

35° ahop

nbncndnenfngn uinjnknlnmnon

Sloped and decorated This version has refinements to the ascenders as well as an elegant "g" form; note the choice of arch shape on "n."

ɼ a b c d e f g h i j k l m n o p q r s t u u v w x y y z ß ꝛ ! ? ; ē ü é

35° 40° ahop

ubncndnenfngn uinjnknlnmnon

Smoother A plainer version with smooth arches, and fine hairlines on the ends of ascenders made by skimming on the edge of the pen.

ɼ a b c d e f g h i j k l m n o p q r s t u v v w x y y z ß ꝛ ! ? ; ē ü é

35° 40° ahop

nbncndnenfngnh hninjnknlnmnon

Lightweight At five nibwidths this looks quite different; curved tops to ascenders and a plain "y" form; the "f" vertical is given weight with an extra stroke.

ɼ a b c d e f g h i j k l m n o p q r s t u v v w x y y z ß ꝛ ! ? ; ē ü é

40° 45° ahop

ʃ a b c d e f g h h i i j k l m w
n o p q r r s t u v w x y z
ß ꝛ ! ? ; c̄ ü é

35° 40° **ahop**

*anbncndnenfn
ngnhninjnknl*

Wider A more open form with some rounded features and extra decorative hairlines; not the overlapping top stroke of "g" and the foot of "h."

ʃ a b c d e f g h i j k l m n
o p q r s t u v w x y z
ß ꝛ ! ? ; c̄ ü é

40° **ahop**

*anbncndnenfng
gnhninjnknlnn*

Upright Written slowly and without slope, with a horizontal finish to ascenders. Pen twists for "f," "g," "v," "w," "x," "y." Elegant hairline descender for "g."

ʃ a b c d e f g h i j k l l m
n o p q r s t u v w x y z
ß & ! ? ; c̄ ü é

40° 45° **ahop**

*anbncndnen
fngnhninjnk*

Swelling Thick strokes are subtly swelled by pen pressure, blended into pen-manipulated thin strokes and very elegant hairline extensions.

ʃ a b c d e f g h i j k l m n
o p q u r s t v w x y z
ß d ! ? ; c̄ ü é

35° 40° **ahop**

*anbncndnenfn
nlnininjnknlnno*

Lightweight, pointed Four nibwidths, compressed and sloped, emphasizes sharp points. Hairlines pulled back onto the letter; note top of "g" and bottom of "b."

A

ABCDE
FGHIJ
KLMN
OPQRS
TUVW
&XYZ

Italics

Based on an oval "o," the compressed letterforms of formal italic have springing arches (branching two-thirds up the stem). They are written at a 5-degree slant with a pen angle of 35–45 degrees, and minimum penlifts to each letter.

Italics are the most versatile hand to the modern calligrapher and can be used for formal scrolls and certificates, or for more expressive forms of calligraphy.

They evolved in the early 15th century during the Italian Renaissance, a cursive hand developed from the Humanist minuscules. The origins of both letterforms lay in the 9th–10th century Carolingian scripts. Italic capitals, based on classical Roman capitals, are compressed and sloped.

Left: An automatic pen and masking fluid was used for "A," fine lines created with the pen corner. The "swash" capitals are written in gouache on an acrylic ink background wash. *Calligraphy by Janet Mehigan.*

bncndnenfngnhninjn nlnmnonpnqnrnsnt

Formal Five nibwidths and sloped. Write at 45 degree pen angle. Smooth oval arches spring from about ²/₃rds up x-height stem. Write slowly.

abcdefghijklmnopqrstu vwxyz ß&!?,;èüé

45°

ahopp

nbncndnenfngn injnknlnmnonp

Lightweight, expanded Pen angle of 30 degrees to produce a rounder, wider letterform. Eight nibwidths x-height makes it lightweight and spacious. Small hook serifs.

abcdefghijklmnop qrstuvwxyz ß!?,;& ěüé

30°

ahop

ncndnenfninjnklnmnonpnqnrsntuvnwn nznanbncndnenfnininjnknlnmnonp

Compressed angular Written with steep 45 degree pen angle and very compressed to create dense, pointed letters. Space inside and around letters should correspond to make even texture.

abcdefghijklmnopqrstuvwxy z ß!?,; ěüé

45°

ahopp

nbncndnenfngnh injnknlnmnonp

Sharpened, expanded Standard five nibwidths x-height and 40 degree pen angle. It appears lightweight because of its expansion. Note the low springing arches and pointed, angular letterform. Sharp serifs.

abcdefghijklmn opqrstuvwxyz ß! ?,; èüé

40°

ahop

abcdefghijklmnopqr
stuvwxyz ß&!?, ĕűé

40° *ahop*

anbncdnenfngnhnijkn
nmnonpnqnrnsntnun

Formal, flowing Six nibwidths
x-height and 40 degree pen angle
produces open, oval style. Arched
ascenders make it look elegant and
flowing.

abcdefghijklmno
pqrstuvwxyz ß&!
?; ĕűé

30° *ahop*

anbncdnenfngnhninjnkn
nonpnqnrnsntnunvnwn
ynznanbncdnenfngn

Heavyweight Four nibwidth letter
height creates a denser letterform. The
30 degree pen angle and expanded
letters gives a rounded squat shape
similar to Carolingian.

abcdefgggzhhijkklm
nopqorstuvwxyyz ß

30° *ahop*

anbncdnenfngnhninjnknlnm
nonpnqnrnsntnunvnwnxnynza

Flourished Standard five nibwidths
and 30 degree pen angle. Write with
rhythm and confidence. Allow extra
space betweeen lines and write using
whole arm movement. Fun to try.

ABCDEFGHIJKLM
NOPQRSTUVWXYZ
ß&!?;ÈĔŰÉ

30° *AHOP*

DIFFICILE EST VERUM
EFFICIAS DIFFICILE

"Swash" capitals Use whole
arm movement and write with
confidence – sweeping into the letter
or out, extending the letters only
where it seems natural. Use sparingly
and thoughtfully.

ndnenfignhninjnknlnmnd
qnrnsntnunvnwnxnynzna

Free Written quickly but with few penlifts, making the arches emerge halfway. Note arches are asymmetrical but smooth, not pointed.

abcdefghijklmnopqrst
uvwxyzß&!?;èüé

45° *ahop*

bnendnenfignhnu
bnendnenfignhnu
knlnmnonpnqnr

Expanded, sloped Although standard nibwidths, the expansion makes this look lighter. Corners of letters are quite pointed.

abcdefghijklmn
opqrstuvwxyz
ß&!?;èüé

30° *ahop*

bnendnenfignhnunynk
nnonpnqnrsntnunvnu
xnynznanbnendnenfngn

Heavy expanded Written at four nibwidths and a pen angle of 20 degrees, creating a wide, round letterform with a heavy linear quality.

abcdefghijklmn
opqrstuvwxyz ß&
!?;èüé

20° *ahop*

ncndnenfngnhninjnknlnmnonpnqnrns
ntunnvnwnxnynznanbncndnenfignhni
jnknlnmnonpnqnrnsntnuynwnxnynz

Pointed, compressed A 50-degree pen angle with a compressed shape makes a dense look; points come easily, end letters with an upward flick.

abcdefghijklmnopqrstuv
wxyz ß&!?;èüé

50° *ahop*

ABCDEFGHIJKLMN
OPQRSTUVWXYZ ß&
abcdefghijklmnopqrstuvwxyz
èüé!? 30° 45° 80° *ahop*

ndnenfngnhninjKnlnn
nopnqRnsntnunvnwx

Compressed, flicks This is a pointed, compressed style written at speed with a pen twist on downward strokes to flick off at the bottom to a point. Use wide capitals for contrast.

abcdefghijklmnopqrst
uvwxyz ßℛ!?;;èüé 30° *ahop*

unbncndnenfngnhninjnk
npnqnrnsntnunvnwnxny
mcnanbncndnenfngnhni

Shallow, looped Only three nibwidths, but letter shapes are compensated by their width; interest is added by the looped ascenders and descenders.

ABCDEFGHIJKLMNOPQRSTUVWXYZ ß&!?
abcdefghijklmnopqrstuvwxyz
;èüé 60° *ahop*

Anbncndnenfngnhninjnklmno
rnwnxnynzAnbncndnenfugn

Tall, thin Seven nibwidths for lower case and ten for capitals makes a narrow, pointed alphabet written with speed; all finishing strokes go sharply upward.

abcdefghijklmnopqrstu
vwxyz ß&!?;èüé 45° *ahop*

anbncndnenfngnhninjnknlnmn
rnsntnunvnwnxnynznanbnc
nhninjnknlnmnonpnqnrnsn

Lightweight, fun Eleven nibwidths means little difference between thick and thin – flick serifs add interest. Keep all corners round, not pointed.

abncndncnfngnhinj

nlnmnonpnqnrnsn

Pressure and release Careful control of pen pressure is needed to produce subtleties of form. Note the curve of "m" and "n."

a b c d e f g h i j k l m o n p q r s t u v w x y z é ű è ahop

A B C D E F G H I J K L M N O P Q R S T U V W X Y ß Z & ? ! ; É Ű È

tnunvnwnxnynanbncnd

anbncndnenfgnhninj

Pen manipulation Subtle thick to thin strokes, especially on ascenders, are made by twisting the pen. Note how the top of ascenders is reverse of "m" and "n."

abcdefghijklmno pqrstu vwxyzß& !?; èüé ahop

30° 45° 60°

anAnbncndndnenfr

onhnijnknlnmnopnq.

Monoline Written with speed, with a ruling pen which allows the free flow of ink in this handwriting style.

ABCDEFGHIJKLMNOPQ RSTUVWXYZ abcddefg hijklmnopqrstuvwxy&z ß!?;èüé ahop

nbncndnenfngn

ninjnknlnjnmon

nqnrnsntnunvn

Heavyweight Only four and three nibwidths means that these letters have become wider to compensate, making a chunky expanded style, with flat feet and some hairlines.

ABCDEFGHIJKLMN OPQRSTUVWXYZ & abcdefghijklmnopq rstuvwxyzß!? ahop

30°

Copperplate

Copperplate, also known as English round hand, is oval in shape with a steep slope and a flourished style which has been developed from italic as an engraver's script from the 17th century. You hold the special flexible pen totally differently from the broad-edged kind. Turn the paper and your hand so the pen is directly in line (parallel) with the steep 55° writing slope. Pull down toward you while applying pressure for downstrokes, and use very light pressure for the upward strokes so you do not dig into the paper.

The ascenders and descenders are twice the x-height of the lower-case letters, and the capitals come about the same height as ascenders. Use Copperplate for formal occasions and for projects that allow its decorative aspect to be shown to advantage.

A B C D E F G H I
K L M N O P Q R S
T U V W X Y Z

a b c d e f f g h i j k l m n o

p q r x s t u v w x y z

£ ! & : ; " " ? ß ë û õ é è ()

0 1 2 3 4 5 6 7 8 9

Overleaf: The complexity of this design becomes increasingly apparent as you follow some of the decorative outer flourishes and find where they originate. Careful planning and skilled penmanship have resulted in a thing of beauty. *Calligraphy by Frederick Marns.*

Aa Bb Cc Dd Ee Ff Gg Hh Ii Jj Kk Ll Mm Nn Oo Pp Qq Rr Ss Tt Uu Vv Ww Xx Yy Zz ß & !?; è ü é

wsanbpenifxcstwyko nmcedyrsqufiturwg

Strong dots The capitals have a pronounced dot at the left-hand edge of their flourish; modest flourishes keep this version comparatively simple.

Aa Bb Cc Dd Ee Ff Gg Hh Ii Jj Kk Ll Mm Nn Oo Pp Qq Rr Ss Tt Uu Vv Ww Xx Yy Zz ß & !?; è ü é

ianbmeufasxptr mveiyxcwrjiolfge

Heavyweight This version is trickiest; weight is achieved by a double line and filling in! The weight allows "B" and "D" to have one joined flourish without letter distortion.

Aa Bb Cc Dd Ee Ff Gg Hh Ii Jj Kk Ll Mm Nn Oo Pp Qq Rr Ss Tt Uu Vv Ww Xx Yy Zz ß & !?; è ü é

iwxcrwpoqnwstvn ifnlvurwmyteuxiu

Mediumweight Make two strokes for the heavy lines if you cannot achieve it with pressure. Flourishes on capitals are short self-contained curls; the points of "M" and "N" are looped.

Aa Bb Cc Dd Ee Ff Gg Hh Ii Jj Kk Ll Mm Nn Oo Pp Qq Rr Ss Tt Uu Vv Ww Xx Yy Zz ß & !?; è ü é

abceuomgtuswxpiy mwgtruilxczbnyspu

Wider Slightly more open laterally, standard weight, flourishes in the capitals are more open; the dots are small but make a nice pattern.

abcdefghi

ABCDEFG

Aesthetics

Composition and design

*W*hen you have gained some expertise in writing a particular style, you will want to do something with it; start with a notice, perhaps, or a short quotation. Whatever you choose, the placing of the words on the page will have as much impact as the making of the letters.

Appropriate layout

The way you plan your design will be determined to some extent by the meaning of the words.

For example, a notice for a restaurant requesting patrons not to smoke needs to be clear and business-like, and with script that is easily read at a glance. The layout should have enough margin to allow the eye to focus on the block of words quickly and to take in the meaning instantly. Contrast that with a quotation about mists at dawn in the meadows. Here would be an opportunity to express the mood by choosing soft muted colors, spacing the words generously across the page with equally generous margins, and, if you have learned one, choosing a soft, lightweight, flowing style of script. A soft, flowing "no smoking" sign and a solid-impact interpretation of mists would be inappropriate. Thus, composition and layout, combined with choice of script, have a strong influence on the way your words are received.

Principles of design

Thumbnail sketches can be helpful in getting your first ideas onto paper. They help to work out the composition in an overall way; always include the edges of the paper as part of the composition, looking at where the bulk of the text sits in relation to the margins. Try several ideas, perhaps a landscape and a portrait format.

Balance

The simplest balanced arrangement is a centered layout, where all lines of writing are arranged symmetrically, against a central line. There are other ways of balancing, however, by arranging areas of text to counterbalance each other visually, making asymmetrical balance. To decide if a layout is balanced, stand back from it so that you can see it as areas of dark and light, or lines of text, and ask yourself if it is tipping over optically.

An exciting freeform alphabet design written with a wooden stick; note how the ABC asymmetrically balances the XYZ, and the weight contrasts give extra interest. *Calligraphy by Werner Schneider* ▲

A deceptively simple, central focus to the beautifully embossed design with lighter elements above; small spread-out letters at the base provide a visual stop. *Calligraphy by Dave Wood* ▶

Margins

Your calligraphy needs breathing space. Do not crowd your design by going too near the edges of the paper. As a general rule, there should be more space around the text than anywhere within; start by measuring the widest white area within the design, then add at least half as much again and make your top margin. The bottom margin should be more than the top, by up to twice as much. If the layout is portrait (vertical), the side margins should be at least as wide as the top margin, preferably more, usually the sides are halfway between the top and bottom measurement. For a landscape (horizontal) layout, the sides may need more margin, maybe as much as the bottom.

Contrast

A layout can look a little dull if it has been done entirely in one size. Using an area of large writing as a contrast to the main text can make all the difference and creates visual interest.

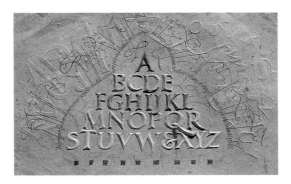

Focal point

When looking at a design, the eye looks for something to rest on as its starting point. This will be the focal point, and can be created by a change in color, weight, size, or position, or any combination of those. Take care when interpreting your text that you do not confuse the eye by using several equally noticeable focal points which are all shouting for attention. Decide on their order of importance and make sure they are differentiated to reflect that priority.

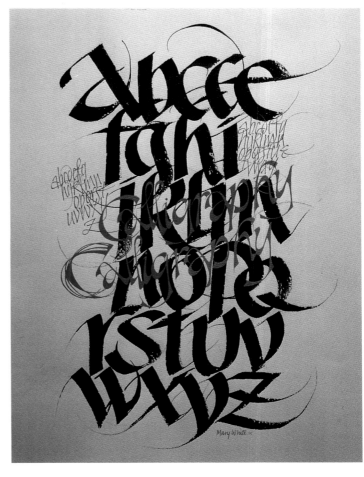

Solid letterforms placed in a compact block are complemented by small, lightweight text areas, and bold overwriting giving contrasts of color, size, and form. *Calligraphy by Mary White* ▲

1

Planning layouts

Always plan a layout by making sketches. Think about balance, margins, content and context, as well as focal point. ▲

3

8

5

6

7

9

1 Heavier or larger writing provides contrast and focus

2 Contrast of two blocks of text

3 Contrast also works this way around

4 Three focal points fighting for attention

5 Main focus is clear

6 Centered layout – have good margins top and sides, with more at bottom

7 Aligned left

8 Asymmetrical; lines of writing are counterbalanced

9 Asymmetrical positioning on page for eyecatching effect

From thumbnail to finished work

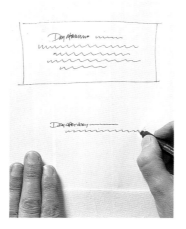

1 Sketch your ideas for layouts of the text you want to write. Bear in mind the amount of text and whether it needs to be broken into certain line lengths such as in a poem. Try vertical (portrait) and horizontal (landscape) layouts.

2 Write the whole text on practice paper without thought to layout; check spelling, letterforms, and spacing, and rewrite anything faulty. Here, the focal point will be the first three words, so they are written in a larger pen.

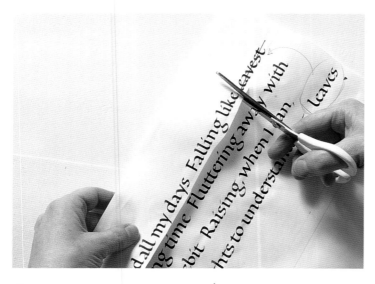

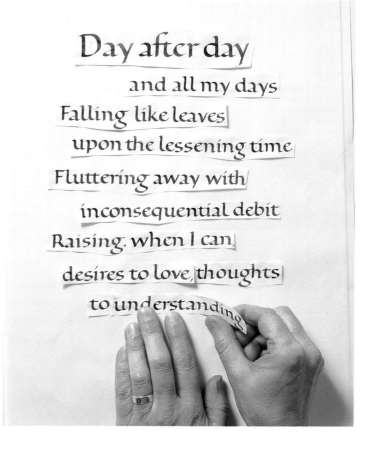

3 Cut all the writing into strips, removing errors; cut carefully to remove excess paper which could hinder your spacing – you may be deceived into spacing too widely to accommodate the paper edges.

4 Arrange the strips of text on a fresh sheet of paper to see if one of your thumbnails works in practice; this is a vertical arrangement with focal point at the top.

5 Now pay attention to margins, as they can improve or spoil a design. Use some strips of black paper or "L" shapes cut from an old matt board (mount). Here the margins are too close, giving a cramped look.

6 Here the margins allow enough space and a chance for the eye to focus on the overall shape of the design. When deciding on margins, start close in and gradually move outward until you can see the overall shape of your design. Remember to leave more space at the bottom.

7 Now rearrange the words for a different layout; in this version the lines are longer and pulled out in an asymmetric design, with an attempt to balance the white gaps evenly with the lines of text and giving a generous margin (more needed on the right still!).

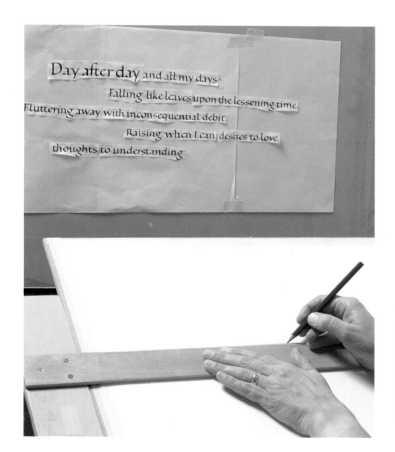

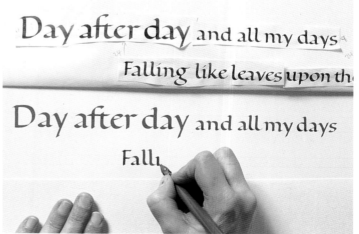

8 When you have settled on your layout, paste the strips in position, checking that your spacing is even between the lines. Mark all your measurements and the pen sizes used. From this guide, rule the lines on good-quality paper for the finished version.

9 To make sure you keep to the original plan, fold over your guide sheet to show only the first line of text and line it up above where you start to write. Re-fold the guide to reveal subsequent lines as you progress; be careful as you move it not to let it smudge your writing.

Alphabetical designs

bstract alphabetical design allows you to explore the visual dynamics of letters placed upon paper without worrying about reference to the language content. Instead of designing a layout for a lively quotation or an interesting, evocative piece of poetry, the concern is only with the visual impact of the solid letter shapes and the space, or interruption of space, which surrounds them; the positive and negative and their relationship with each other is the basis of good design.

It also serves as an exercise in imaginative design, for it is the placing of the shapes rather than the meaning of the text that will suggest excitement, spontaneity, tension, precision, or tranquility.

Since it is not primarily meant to be read, there is also plenty of scope for you to explore ideas of color, technique, rhythm, and feeling.

Look at some of the work produced in this book and try some of the ideas.

Letter textures

In calligraphy the overall aim is to produce a uniform texture of words, using black and white, which is aesthetically pleasing. Studying letterforms carefully and understanding their construction will help you achieve this. Having gained a skill, you can become more imaginative and creative.

There are many variations to consider, and often the words of the text itself can offer inspiration, by suggesting color changes or illustrations. However, the letter construction, weight, and height can be altered and explored.

The ratio of nibwidth to letter height that you will learn is a rule only until you understand what happens to the shapes; then the rules can be thoughtfully and purposefully changed. The changed weight of a letter can give a different "feel" to text. This is because the space around and inside the letters is also changed.

Decreasing the nibwidth height will make the text more dense; increasing the nibwidth height gives the letters more space, making them appear lighter. Compress the letter widths with the surrounding space and observe what happens to a line of written text. Write these same letters in a block to see how different they can appear. Words can be expanded, enlarged, or narrowed. Text can be made to stretch, tighten, and dance. Experimenting with letterforms should be analytical, constructive, and consistent.

These dancing, flourished italic letters form an interesting spiral, intermingling and moving together to produce a flowing design. *Calligraphy by Ros Pritchard* ◀

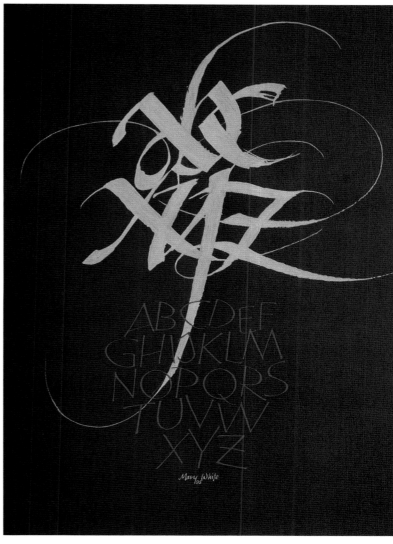

This letter "D" is full of vitality and excitement. Executed with great confidence using a ruling pen and black ink. Further interest is added by using an automatic pen for the weighted areas. *Calligraphy by Rachel Yallop* ▲

There is a tension created in the vigorous, interwoven top letters which then links with the more precise and careful design in the alphabet below, giving this panel two distinct elements. *Calligraphy by Mary White* ▶

Freely written, compressed cursive italic gives a strong, almost vertical rhythm to these letters. The introduction of the exaggerated round shapes produces an interesting change of texture. *Calligraphy by Peter Thornton* ▲

The imaginative use of space and weight in this alphabet creates a delightfully elegant and subtle alphabet. *Calligraphy by Peter Thornton* ▼

Interpreting the text

*L*ook at the textures in the Script Identifier and analyze the changes. Different textures can be created within the text to convey a variety of ideas. Closely written Gothic text creates a heavy, black textured page and invites a different response from the delicate, flowing letters of italic.

Texture and rhythm can be seen all around us. Make notes of what you see and make small thumbnail sketches; keep cutouts from magazines and papers, take photographs of objects, lettering, other crafts: save pieces of colorful and textured fabric, colored paper bags, and unusual papers, in fact anything that interests or stimulates you. Create your own library or file of ideas; it will encourage you to

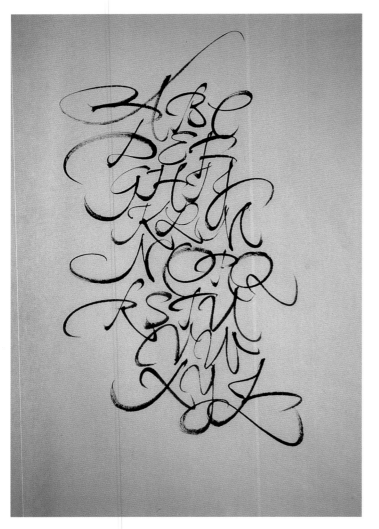

become more aware of your surroundings. Learn how to observe and analyze. Use what you discover in your designs.

Study the work of other calligraphers and other arts, such as silkscreen printing, fabric designing, weaving, embroidery. Walk along the beach and study the pattern of pebbles, or in the countryside and look at the structure created by hedges and trees. Observe sunsets, analyze the sequence of colors, very pale blue, bluish-red, pale yellow along its edges. When they are carefully and lightly blended, orange hues emerge. It is a very subtle change.

Look at the ripples on water and notice the

il is the essence of

is the essence of conservatism)

narked by supreme confidence

hibits so fiercely, or shrinks a vision

so swiftly as fear of failure

A L B E R T · J · S U L L I V A N

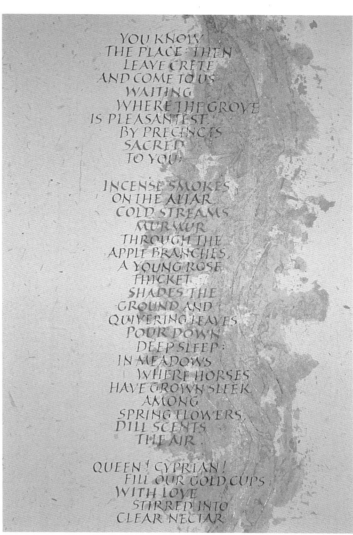

YOU KNOW
THE PLACE THEN
LEAVE CRETE
AND COME TO US
WAITING
WHERE THE GROVE
IS PLEASANTEST
BY PRECINCTS
SACRED
TO YOU;

INCENSE SMOKES
ON THE ALTAR
COLD STREAMS
MURMUR
THROUGH THE
APPLE BRANCHES,
A YOUNG ROSE
THICKET
SHADES THE
GROUND AND
QUIVERING LEAVES
POUR DOWN
DEEP SLEEP;
IN MEADOWS
WHERE HORSES
HAVE GROWN SLEEK
AMONG
SPRING FLOWERS,
DILL SCENTS
THE AIR

QUEEN! CYPRIAN!
FILL OUR GOLD CUPS
WITH LOVE
STIRRED INTO
CLEAR NECTAR

way they run and what colors there are. Water is rarely all blue – there are browns, greens, and light (white).

Nature offers some very simple answers if you are prepared to look for them. Study a red rose and its leaves. The leaves are not green as you first thought; they contain vast amounts of red, as does the flower. The color red permeates into the green, changing it in many areas.

The imaginative use of color and color techniques, and the unusual letterforms, convey very well the text of this quotation by Albert J. Sullivan. Written on Arches CP watercolor paper using gouache and art masking fluid. _Calligraphy by Timothy Botts_ ◄

This beautifully designed and executed alphabet of capitals shows a personal and individual italic letterform which is extremely lively and flowing. _Calligraphy by Werner Schneider_ ◄

The use of color enhances the meaning of the text in this fragment of poetry by Sappho. The subtle color changes in the writing also appear randomly throughout the background. Freely written italic capitals. _Calligraphy by Ros Pritchard_ ▲

The principles of color

Color has a strong influence on our lives and the way we feel and behave. It is strongly linked to mood and thought. Red suggests anger, excitement, danger, impulsiveness, and passion. Blue can suggest serenity and coolness, and black indicates sobriety and formality.

Think of the seasons: greens for spring, yellows for summer, browns and reds for fall (autumn), and blues and grays for winter. Already we have a palette of colors to describe our written words.

It is well known in the color sciences that color conveys a richer degree of information than black and white imagery. Observe your own response to carefully planned color advertising and black and white.

Any visual piece of work can be enhanced by the addition of color. It may be used in the writing itself, in the form of border decoration, as a subtle or vibrant background, or as illustration. Careful and thoughtful use of color can produce harmony, set a mood, emphasize an idea, or create a dramatic feel about the subject that is being conveyed.

Using color in your work successfully will depend on your knowledge of materials and techniques, and how suitable each will be to the subject matter and design.

Designing with color

Bright colors shout for attention; light, soft colors can link areas in a design in a subtle way. When you begin, avoid using too many colors; limit yourself to a maximum of three. If the writing is very uniform and simple, two or three colors can be used without overloading the design. If, however, the writing is very varied in texture, weight, and letterform, only use one color. Too many elements in design cause confusion, making it difficult to locate a focal point. The focal point is the statement you are making with your work.

A small delicate panel of freely
written italics in indigo gouache
plus black ink. The subtle colored
shapes in and around the letters
are painted in watercolor. Note
how the letterforms progressively
increase in size and freedom.
Calligraphy by Brian Walker ◀

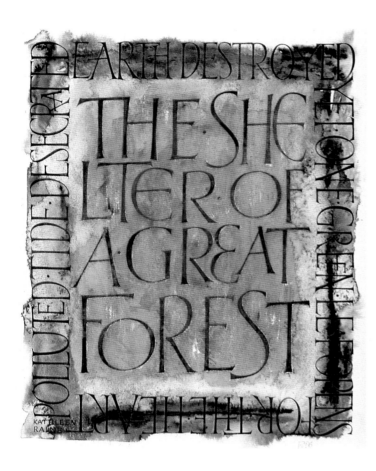

Russian icons were the inspiration for this colorful and dramatic panel of a poem by Kathleen Raine. It has an almost 3-D quality in its texture. Drawn and painted letterforms over watercolor washes. *Calligraphy by Polly Morris* ◄

A sensitively designed panel using only one letter of the alphabet. Beautifully executed with fine, controlled lines. Highlighted with small rectangles of raised gold and color on a delicate background of crosshatching. *Calligraphy by Gaynor Goffe* ►

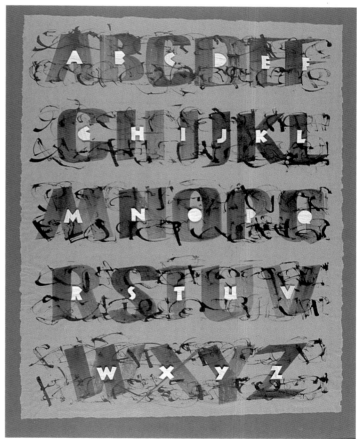

In this unusual piece, large torn paper shapes provide a great contrast to the delicate well-executed capitals and their finely formed serifs. *Calligraphy by Brian Walker* ▼

Heavyweight, freely written capitals. Subtle color changes in the letters add to the interest, as does the background texture. The smaller white letters offer a contrast. *Calligraphy by Godelief Tielens* ▲

Choosing and mixing colors

The range of color and media in an art supply store can be overwhelming. All media – watercolors, gouache, acrylic inks, pastels, pencils, watercolor pencils – can be used in calligraphy. With practice they can be used in combination. Manufacturers create most of their different lines (ranges) to match, although confusingly, they are not always called by the same names.

To make mixing easier, it is advisable to begin with six colors; two reds, two blues, and two yellows. This will allow a greater degree of understanding when mixing colors is required.

In effect you are dividing each primary color into two. Cadmium red contains a little yellow (orangey-red), alizarin red contains blue (bluish-red). Ultramarine contains red (reddish-blue), cerulean blue contains yellow (yellow-blue),

lemon yellow has a blue tinge, and cadmium yellow contains a small amount of red.

The color wheel is made up of red, blue, and yellow, the three basic or primary colors, so-called because they cannot be made by mixing other colors. When they are mixed together in equal amounts, they produce three secondary colors. Red and blue create violet, blue and yellow produce green, and yellow and red make orange. If you are unfamiliar with color, try mixing violet, green, and orange.

Then by mixing a primary color with a secondary, a tertiary color is produced. Try it yourself; you should now have twelve different colors.

By mixing the colors directly next to each other on the wheel, you will produce the purest orange, violet, and green. Therefore, by mixing alizarin red and ultramarine, for example, the

The color wheel

The color wheel shows how all colors derive from three basic colors – Red, blue, and yellow.

Complementary colors

These colors are directly opposite each other on the color wheel. The complementary color of blue is orange. Another way to remember is to say that the complementary color of blue is the mixture of the two other primary colors. Red and yellow = orange.

Analogous colors

Analogous colors are next to each other on the color wheel. For example: blue, blue-violet, and violet. When they are used together, they create an harmonious effect and mood. The theory that the three primaries actually make all colors is rather simplified, and to understand color mixing really well, it would be best to start with six basic colors.

Understanding mixtures

When colors are placed next to one another you can see the color bias clearly, as the artwork near left demonstrates. The swatches show how the choice of primary color affects the mixture. Those closest together on the wheel create intense secondaries, while those furthest apart create neutrals.

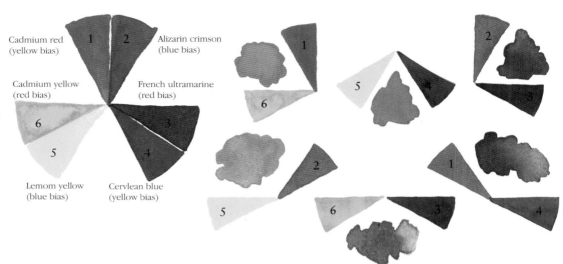

Cadmium red
(yellow bias)

Alizarin crimson
(blue bias)

Cadmium yellow
(red bias)

French ultramarine
(red bias)

Lemom yellow
(blue bias)

Cervlean blue
(yellow bias)

best violet or purple will be produced. Try mixing cadmium red and cerulean blue, and you will discover that red and blue do not make purple. This mix produces a warm gray or brown, depending on the amount of each color you use. Try different mixes. Make notes about the colors you used and what was produced and keep them as a reference. For example complementary colors create visual vibration. Green letters on red are difficult to read because they neutralize each other when used in equal amounts. However, they can appear to advantage used in small amounts, as they add vibrancy to the page.

Watercolor

For subtle illustrations or for background washes, watercolor works well because it is generally transparent when it is applied. It is also light when it is used in the pen, producing a slightly watery effect.

Gouache

Although gouache is basically the same as watercolor, it has a white pigment, or filler, added to render it opaque, which allows denser flat cover when used. It is preferred by graphic designers and is ideal for using in pens and for bright illustrations. However, it tends to streak when it is used with a brush to create thin washes. Through experience you will understand the properties of both.

Acrylic inks

The use of acrylic inks for color work is fairly new. Although they tend to be generally too thin for writing small letters, they are very effective when used with larger pens, particularly when

the colors are blended like watercolors. They are bright and permanent once they have been applied and provide a good, stable background on which to write. They can be used very dilute for several washes or direct for vibrant effects. Always rinse brushes and palettes, and clean pens.

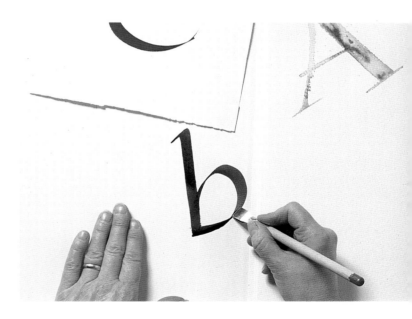

Using different media

Writing letters in different media will allow you to appreciate the qualities of each. The letter "A" written in watercolor produces a transparent effect. "B" written in acrylic ink is shiny and smooth, and waterproof. "C" written in gouache creates a flat, matt, and denser color.

Writing with color

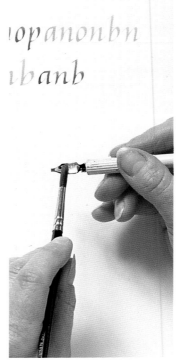

1 Mix the color to the consistency of light (single) cream, which will be thicker than ink. Be sure to mix enough to do all the writing. When two colors are mixed together, it is always difficult to mix more of the same blend because color varies from wet to dry.

2 Add the color with a brush from the side or from underneath. Adding color to the top of the nib (unless it has the reservoir on top – a Brause nib) will cause the paint to blob.

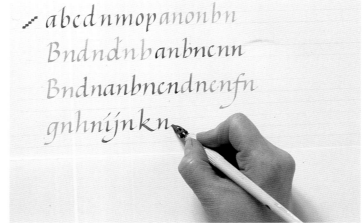

3 When the paint just begins to thin, replenish it by adding more paint to the nib with the brush. Two or more colors can be used to create very interesting effects.

4 Each time a change of color is needed, rinse your brush (or better still, use a separate brush) before adding a second color to the nib. The original color and the new color will blend as you write, making a gradual change which is generally better than an instant change, although in some cases you may want a sharp division.

5 Other colors can be added in the same way to create soft color blends.

6 Try using analogous colors that sit together on the color wheel, such as orange-yellow and cadmium red.

7 Make shades of one color such as dark to light blue by adding white.

8 Use two complementary colors, such as blue and orange, red and green, or yellow and purple and yellow. This will create a vibrant effect.

9 Here orange and blue were used, then pastel was dusted on in the same colors to highlight the composition.

Writing on colored backgrounds

Colored papers can be used for single background color. For additional interest, cut or torn pieces can be stuck on with PVA or craft glue to create contrast. A whole collage can be built up and then written upon. However, you may wish to create your own background color from paint or inks.

Background washes

Creating background color with washes requires practice to understand all the possibilities. Washes need a great deal of water, which will wrinkle the paper unless it is "heavyweight" (260 lbs or 356 gsm). Lightweight paper will probably need stretching.

Using stencils

Soft pastels can be used through a stencil cut from cardboard or acetate. Soft repeat patterns can be created. It is not necessary to use fixative, and the surface can be written on without problems.

Pencils

Graphite pencils, colored pencils, and watercolor pencils can be used by carefully building up layers of color. They can also be mixed with other media, particularly watercolor pencils. Watercolor pencils can be used dry and then wetted with a damp paintbrush when the design is finished. This gives more control, and some areas need not be painted, which gives a varied finish.

Eraser stamp designs

These are made by cutting an eraser with a craft knife or linoleum cutting tool. Then the eraser design is pressed onto a purchased or homemade stamp pad soaked with paint or ink and then pressed onto the paper to repeat the pattern. Any small motif can be used. Remember the design will be reversed when it is printed. The area that is cut out and discarded will remain white. The relief or raised area will be the part that prints.

Use eraser stamps and pastels or paint through stencils to decorate areas within the design. Care must be taken with the overall effect of illustration in the piece of work. The illustrations or motifs must not be too large or too numerous for the design, and should never be added to the work at the end to "fill a space." Any motifs, borders, or illustrations must be considered at the planning stage of the work.

Hot-dyed paper

Paper can be colored by immersing it in a boiling dye solution. Often the coloration has interesting variations, probably caused by the way the boiling dye moves over the paper surface. After being dyed for a few minutes, the paper should be washed under running water and dried under light pressure between sheets of blotting paper.

In this example, the watercolor background has been added after the lettering has been done.

To create a textural effect, coarse sea salt crystals were sprinkled over the wet paint

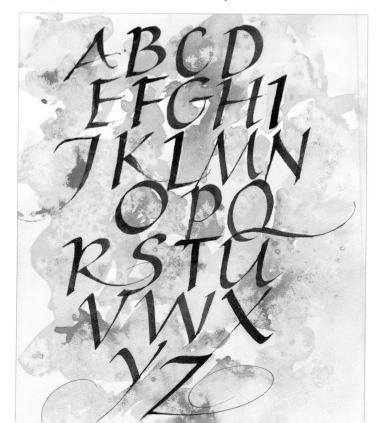

Stretching paper for background washes

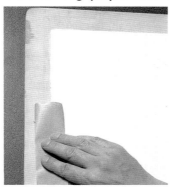

1 Make sure the board is slightly bigger than the paper to allow for the tape.

2 Carefully place paper in cold or tepid water, keeping it flat. Leave it for a few minutes to make sure it becomes thoroughly wet.

3 Holding two corners, lift the paper from the water and let the excess water drain. Place carefully on the board, lowering gently to exclude the air.

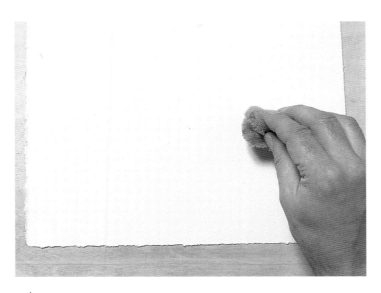

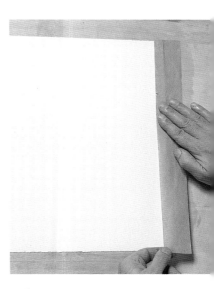

4 Use a sponge with great care to blot the surface. On a large sheet of paper, always work away from the center. Do not apply any pressure; this will damage the surface.

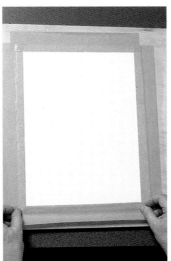

5 Cut four strips of gummed paper tape to place along the four sides of the paper. Wet each piece of tape with a fairly damp sponge.

6 Tape one side and then the opposite side. Then tape the other two sides. Allow an overlap of tape on the paper of about ½ inch (10–15mm) and press each down firmly.

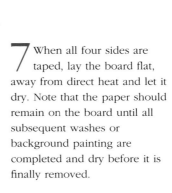

7 When all four sides are taped, lay the board flat, away from direct heat and let it dry. Note that the paper should remain on the board until all subsequent washes or background painting are completed and dry before it is finally removed.

Laying a wash

You will need

Stretched paper
(see page 89)

Large, soft brushes

Watercolor paints

Lots of water

A deep palette or mixing
bowls

Clean water for rinsing the
brushes.

1 Tilt the board about 2 inches (30–40mm) at the top end. Leave the stretched paper on the board. Mix the paint in a bowl with plenty of water. Load a large, soft brush with paint and draw it horizontally across the top of the paper. Do not stop until you have reached the other side.

2 Load the brush again. Now do a second stroke in the same way, slightly overlapping the first stroke. Continue working in this way toward the bottom of the sheet.

3 Do not patch any areas that have been missed. To prevent streaking, there should be enough liquid in each line to create a long puddle at the bottom of each stroke. Overlapping this line fractionally will allow each stroke to blend together.

4 When you reach the bottom, rinse the brush, dab off the excess water, and run it along the bottom puddle to pick up the excess paint. Lay the board flat and dry it as before. If the color needs to be darker, repeat the process.

Laying a graded wash

1 Tilt the board. Mix the paint in a small jar. Load a large brush and draw it horizontally across the paper, continuing directly to the far side. After one or two strokes, add more water to the paint mix.

2 Continue down the paper, adding water to the paint after each stroke.

3 The color should now appear lighter as it proceeds down the paper.

4 Finish the wash by soaking up the watery paint with your damp brush. Lay flat. Once it is dry and you are satisfied with the result, you can remove the paper from the board and write on it.

Laying a two-color wash

1 Mix the two colors required in two separate suitable containers. Tilt the board at the top and lay a wash to the center.

2 Turn the board around and, using the second color, work again to the center, overlapping the two colors slightly.

3 Allow the colors to bleed into one another.

4 The mix of color can be controlled by turning and twisting the board to let the paint blend more readily. Lay flat to dry.

Laying a variegated wash

1 Use a wet-into-wet technique – wet the paper and allow a few minutes for the water to soak in (until the paper looks matt rather than shiny). Meanwhile, mix three or four colors. Load a large brush (No. 8–10) with the first color and paint some areas of paper, leaving other areas white.

2 Rinse the brush and load it with the second color. Dab it into the white spaces. Watch what happens as it blends and moves on the damp paper.

3 More color can be added to desired areas. Brighter color can be added by using thicker paint. If it appears too bright, tone the color down by adding more water. This way you can control the amount and depth of color in the background. Certain colors mixed together cause granulation to occur; try using alizarin red and ultramarine blue.

4 Add complementary colors for vibrance – in this instance, it is purple. For further interest, the board can be tilted and turned to make the color blend and bleed. Desired areas of color can be removed by using dampened cotton balls or a natural sponge.

5 Now that the desired effect has been achieved, lay the board flat to dry. If the results appear disappointing, before the paper dries, wet it (preferably under running water – a shower head is ideal) and carefully sponge the paint away. Dab off excess water. Leave it to dry and begin again.

Colored dye on paper

1 Commercial hot-water dye can be used to produce colored paper. Follow the instructions on the package. Heat dye in metal tray large enough to hold the paper.

2 Thoroughly mix the dye to make sure the paper will be dyed evenly.

3 Submerge the paper carefully and gradually. Try not to bend the paper; the water is hot and any stress will damage the surface of the paper.

4 Leave the paper in the dye for between 1 to 15 minutes, depending on how dark you wish the color to be. Experience will soon tell you how long is required for the desired effect. A light coloring or streaked color will take less time than denser color.

5 Carefully lift the paper by one corner, and let excess water drip back into the container. Rinse carefully in another container. More paper can now be dyed.

6 Rinse the paper carefully under running water until the water runs clear. Take care not to splash because the dye will stain.

7 Lay the dyed paper flat on to blotting paper, and squeeze out the excess water with a roller.

9 Dry in a press by placing a heavy board on top of the paper and lay flat to dry overnight. When it is completely dry, it can be written upon with great success.

8 Transfer the colored paper to clean blotting paper, making sure that it is flat and crease free. Cover with another sheet of blotting paper.

Casein on paper

Casein paint is rollered onto paper to provide a textured and stable background color on which to write. The color is waterproof when dry, so several coats of paint can be applied to build up layers of exciting color and texture.

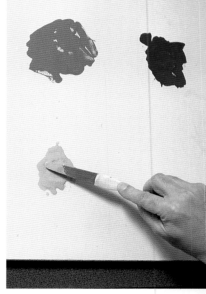

1 Tape the paper to the board to prevent it from moving. This gives you the freedom to use a roller firmly.

2 Choose the colors and squeeze them out onto a large tray or a flat glass surface or, as here, a piece of paper which is easily disposed of when you have finished.

3 Using the roller, mix the colors together to provide interesting blends. Do not roll too much; otherwise, the effect will be diminished.

4 Place the roller on the taped paper and move it back and forth carefully on the paper. Do not spoil the freshness by doing it too much. The color will soon come away from the roller, which is the time to stop.

5 Renew the color, and then moving to another area on the paper, repeat the maneuver, taking care again not to overblend the color.

6 Cover the paper gradually. The roller can be used in different directions to create texture and pattern. When finished leave to dry. Further applications of color can be added using the same technique. This will build up layers of colors on which to write.

Soft pastels

You will need

Paper

Pastels

Craft knife

Cotton ball (cotton wool)

Fixative (optional)

Eraser

1 Soft pastels are used to create soft backgrounds without paint. If you use pastel directly on the paper, lines and streaks will appear. For a soft blending of color, scrape a small amount of pastel onto the paper with a craft knife. Alternatively, rub a piece of cotton ball (cotton wool) on the pastel, picking up the color required.

2 Gently rub the pastel into the surface with a piece of cotton ball. Using a circular movement prevents any unwanted lines from appearing and gives you more control over the media. More pressure can be added to blend the color into the paper. Using a fixative is optional.

3 Continue moving in circles when adding more color, as blending will be easier and smoother. Remove unwanted color with an eraser. Pencil lines removed after writing leave white marks. Touch in with colored cotton buds.

4 Subtle blends of color can be created very expertly with this method of coloring paper. When the pastel is rubbed in firmly there should be little need to use a fixative. Writing with a pen on top is pleasurable as no bleeding or changes of color occur.

Paste and paint

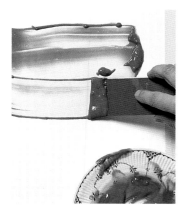

1 Mix a small amount of wallpaper paste and add some paint – gouache was used here straight from the tube – then spread it freely over the paper with a piece of cardboard, moving in at least two directions for good coverage. Experiment with how thickly it can be laid.

2 Use a soft implement such as a piece of eraser and scrape marks or letters into the surface. One color has been used here, and the scraping reveals the white underneath. The slippery surface gives uninhibited free movement. If it goes wrong, re-spread the paste and try again on top. It will dry fairly flat but it will give a 3-D shadow effect along the edges of the letters or marks.

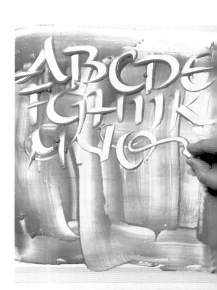

You will need

Paper

Pencil

Tape

Cutting mat

Acetate

Craft knife

Pastels

Using stencils

1 Draw a design on paper. Here a simple flower shape is being used. If you find drawing difficult, trace an idea from another source, using only an outline and keeping the shapes as simple as possible.

2 Tape your design onto a cutting mat or a piece of thick cardboard, so it does not move and to protect the table. Place a piece of acetate over the top and tape it securely.

3 Using a craft knife, carefully cut out the design. The areas that are cut away will be the design made by the pastel.

6 Scrape a second color onto the design.

7 Lift the acetate to see the result. Choose another area for the design and repeat. Continue until you have created the effect that you want. Any number of different colors can be added. Remember to use a clean piece of absorbent cotton (cotton wool) for each color to keep the color fresh.

4 The design can be used to decorate one letter or whole pieces of writing. Using acetate instead of cardboard or a conventional stencil means that you can see where to put each single design. Place the acetate in the chosen position and tape securely. Scrape pastel on the design.

5 Carefully rub the pastel through the stencil, lightly first, then quite firmly.

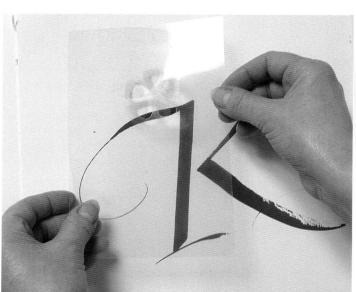

You will need

Soft pencil

Paper

Eraser

Craft knife

Stamp pad

Fiber-tipped pens

Eraser stamp designs

1 Draw or trace a pattern on a piece of paper. Keep the design simple so you can cut the shapes easily. Use a soft pencil.

2 The design can be drawn straight onto the eraser. Alternatively, the paper can be placed pencil-side down on the eraser and drawn again. This will cause the graphite design to be deposited onto the eraser.

3 Remember that the printed design will be reversed. The areas that are cut away will remain white, the raised areas will be colored. Carefully cut the design with a craft knife – cutting away from your fingers!

4 Press the eraser into a stamp pad soaked with ink, then press it onto the paper. Alternatively, colored fiber-tipped pens can be used to paint the eraser first, which can then be stamped onto the paper.

5 Continuous border patterns can be created easily. Changes of color make it more interesting.

6 Delicate leaf patterns and flowers can be created as small motifs for letter headings and cards. Stamps made this way can be used over and over again and in different combinations.

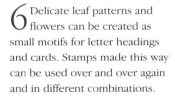

Art masking fluid resist

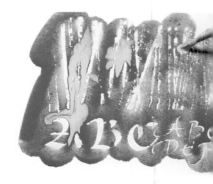

1 Paint will not take to the
paper where masking fluid is
applied Use an old brush, a
piece of cardboard, or cotton
swab (bud) to write with; metal
pens work well and will not be
damaged, but need frequent
wiping to prevent clogging.

2 When the masking fluid is
dry, it appears matt. Then
apply the paint. Lay color
washes on the paper, loading
the brush well.

3 At this stage, while it is still
wet, you could add other
colors – they will run into each
other, so choose colors that
blend well. When you are
satisfied with the result, leave it
to dry completely.

4 Rub away the masking fluid
with your finger using a
gentle circular motion; it should
come away in rubbery strings.
Take care not to damage the
paper surface by rubbing too
hard, especially if you plan to
use this method to develop a
background texture.

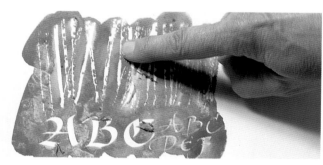

Spatter

Spattering paint or ink over a
surface is the low-tech version of
airbrushing! Very attractive effects
can be achieved with an old
toothbrush or paintbrush loaded
with color and flicked with your
thumbnail or a ruler.

1 Paper cutouts or leaves laid
on the paper will produce
patterns and silhouettes when
they are removed. The reverse
effect would be to spatter paint
through a stencil. Shield yourself
and the work surface.

2 When you have completed
spattering, lift the leaves off
carefully, taking care not to
smudge the paint; consider
developing several layers of
spatter, having moved the leaves
or images with each layer.

3 When you have perfected
the method, consider how
you could use such a decorative
element with some text; in this
example, a poem about falling
leaves would fit well.

Pen patterns as borders

You will need

Papers, plain and colored

Pens

Ink or paint

Glue stick

Repetitive marks can make very interesting and decorative edge patterns and borders. Inspiration for the shapes can often be derived from the strokes of letters that you are using.

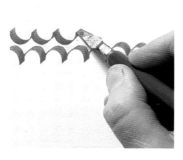

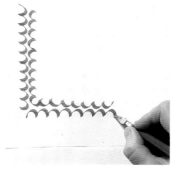

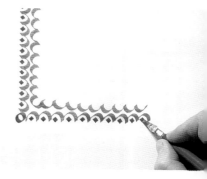

1 Experiment with shapes similar to those you have used for letters, and see how decorative they can become by making them repeatedly. Try repeating the same design the other way up, by turning the paper around.

2 Turn the page at a right angle and continue the patterns at each corner as you come to it. If the pattern is very complex, you may find it easier to stop short at each corner and leave a gap to be filled later with a different shape.

3 When the decorative elements have been completed – here, squares have been added in the outer semicircles – clean up the corners if necessary by adding another related shape, in this case a circle.

Two pens

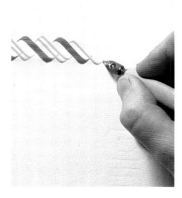

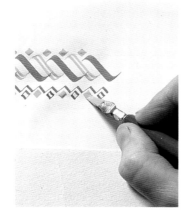

1 A simple repetitive pen stroke can be elaborated by alternating one stroke of a wide pen with two strokes of a narrow one. A second color adds extra interest.

2 Try out smaller, similar patterns underneath, linking the colors and style of the stroke. If you are feeling ambitious, just keep going with more and more patterns!

Using colored paper

1 Colored paper can be used as a background, which can be made more interesting if it is cut or torn. Here soft colors were used. One of the colors is used for the writing to provide continuity.

2 When tearing and positioning the paper, consider the balance of the colored shapes. Trim the paper.

3 Finally apply glue and stick the pieces in place.

Which script?

With so many scripts to choose from, it is difficult sometimes to decide which one will be appropriate for your needs, assuming you have developed a good command of a selection of hands. Personal preference does have a part to play, but think also of the purpose of the piece of work, and the meaning of the words. Gothic, for example, is very decorative, but would be an unwise choice for an urgent notice as it is difficult to read.

Modern styles

While some styles have strong historical associations, they can all be used for modern work; many of the variations shown in the Script Identifier (see page 28) indicate modern renderings. Take care not to mix too many styles on one piece of work, however, as this can look confused.

Combining script styles

It is usually best to confine yourself to one or two related styles in any one piece of work. Several variations of the same style are more likely to unify a piece of work than the same number of unrelated styles. This is largely because of the family resemblances in the way the letters are formed.

For example, several different weights and sizes of italic capitals and lower case, even if they include blocks of variations in style and line spacing, will look more unified than the same text in a combination of say Gothic, Uncial, and Copperplate.

Classical Roman Capitals go with anything, as do Versals based on them. Decorative Versals are used as very attractive initials, rather than in whole words. The most suitable hand to use with an initial depends on its style:
• Roman Capitals, use Carolingian or Foundational, or Italic if it is a modern design.
• Plain Versals, as for Roman Capitals.
• Uncial form of Versal, use Uncial or Half-uncial
• Ornate "Lombardic" style, use Gothic.

Matching script to project

Some scripts are more versatile than others; Italic can be adapted to so many variations that it can be made to suit almost any occasion. Others are more specialized. Decide whether the project is formal or fun.

Formal projects

A certificate or formal notice calls for dignified, carefully formed, regular letterforms, giving a fairly static look.

Roman Capitals, Versals, Foundational, Formal Italic (that is, not the nearly joined-up kind), or some Uncials might be good choices, and the more restrained versions of Copperplate. Decorative elements or a flourished initial letter may be included for visual interest.

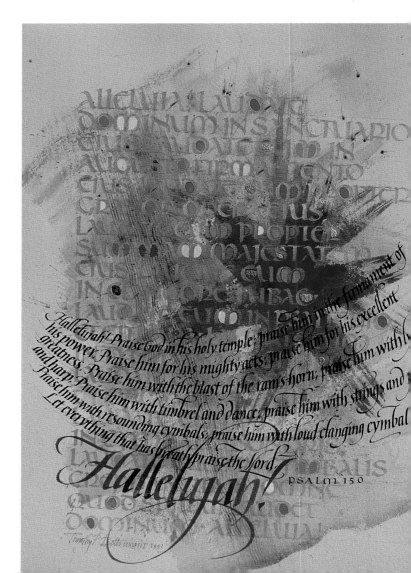

One rule-breaking example where a combination of letterforms has worked because their relative sizes are carefully balanced; note the unusual placing of the focus point at the bottom. *Calligraphy by Timothy Botts* ▶

Historical associations

Sometimes the words you have chosen to write are linked to a particular country or to a past age, making it appropriate to use the hand associated with that link. Some examples are listed here (see also Introduction, page 6).

Roman Capitals – classical; timeless quality.

Uncials and Half-uncials – these are associated with Ireland, Scotland and Northern England in the early Christian era. There are narrower half-uncials, an Anglo Saxon form.

Decorative Versals – the "Lombardic" versions traditionally are used as initial letters only, and go with Gothic text.

Plainer Versals are more like Roman capitals and so have broader associations.

Carolingian – an elegant hand with French connections.

Foundational – a modern interpretation of the 10th century, late Carolingian style: it is mainly used as a formal, contemporary hand.

Gothic – Germany; many German calligraphers still use freeform versions, but the highly decorative kinds have medieval associations.

Bâtarde – late medieval French, a more cursive form of Gothic.

Italic – from the Italian Renaissance; "humanist" versions have an historic feel, but it has become the most popular hand for present-day use owing to its versatility.

Copperplate – 17th and 18th century, the most ornate decorations are associated with Victorian England which combined them with Gothic forms.

ABCDEFGHIJKLMN
Roman capitals

ABCDEFGHIJKLMN
Uncial

abcdefgghijklm
Half-uncial

ABCDEFGHIJKLM
Versal

abcdefghijklmnopqr
Carolingian

abcdefghijklmn
Foundational

abcdefghijklmnopq
Gothic

abcdefghijkllmnn
Bâtarde

abcdefghijklmnopqrst
Italic

ABCDEFGHI
Copperplate capitals

abcdefghijklmnopqrstu

Poetry and quotations

Poems are a favorite subject for calligraphy as they can be interpreted visually, choosing a script which fits the mood and carefully considering the visual effect of the composition.

Italics are very adaptable for interpreting texts in this way – pointed versions evoke anger or frost, while soft, expanded versions give gentle effects.

Carolingian also has a wide, relaxed appearance, and its tall ascenders demand wide line spacing. Some of the Half-uncials have a lively movement and would suit cheerful words, as do the more freely written Uncials.

Copperplate is both controlled and lively, and would suit many situations in place of Italic.

The Bâtarde hands are pretty and decorative and in some cases easier to read than the Gothics.

If the poem asks for a heavy, solid approach, Gothic can sometimes fit the requirement; executed with a very large pen, the regular heavy strokes interspersed with equal amounts of white can give a very sturdy effect, particularly if interline spaces are minimal.

Posters

The function of a poster is to catch the eye, and then to give the salient points at a glance. That eliminates many alphabets of a decorative nature, although they may be used for the secondary information. Size and weight are important – you need impact. Space your main title closely and use a bold hand; group other information so that it reads in logical order.

Heavyweight capitals, Italic, thick Versals, and Uncials would all catch the eye, and then you should choose a smaller, less heavy version or a linked script for the rest of the text.

Greeting cards

Some cards are informal opportunities to play with letterforms, group or repeat words over and over for a pattern effect, make a feature of one letter or a short word, and incorporate decorative borders.

An experimental piece exploring letterforms which vary in size as they lock together, depending on the shape of the previous letter and the counter space. *Calligraphy by Brian Walker* ▲

The nature of the occasion may suggest the choice of script, but ther are no limits. This is a chance to have some fun and experiment with unusual combinations, and to explore the potential of certain hands that intrigue you. If a particular hand excites you but seems inappropriate, try it in a much bigger or smaller size to see if scale makes a difference.

Books

If you have chosen to make a book, choose a hand that looks right in a small size – and one that you can write competently and achieve an evenness of overall texture.

The impact and visual interest are provided by the creative letterforms carefully placed on this uncluttered greetings card design. *Calligraphy by Gillian Hazeldine* ▶

The margins and the interline space will be important factors to consider in a book where every page will look similar; experiment with widening or narrowing the interline spaces, and giving lots of margin.

The usual scripts associated with writing books, referred to as "book hands," are the easily read lower case hands such as Italic and Foundational (if that does not seem many, remember how many versions are available!), but the subject will be the determining factor. An old German story might be appropriate in Gothic and a Scottish folktale may look well in Uncial or Half-uncial.

A perfect illustration of how different twenty-six letters can look. The flamboyant Copperplate is wonderfully delicate and ornate, while the sensual wide-pen version incorporates hairline contrasts and captures the paper texture. Both have breathtaking impact while evoking different moods. *Calligraphy by Jean Larcher* ▼

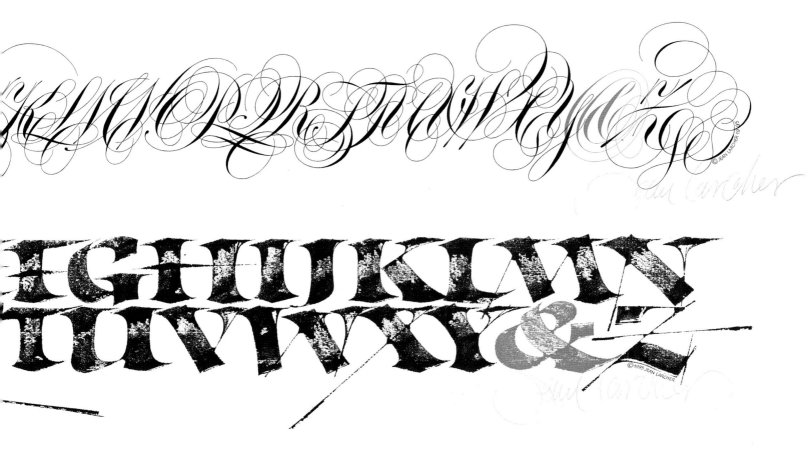

Illumination

The illumination and decoration of manuscripts has a long tradition in the teaching of religious texts. The richness of the gold decoration was used to honor God.

There are still thousands of fine examples to be seen throughout Europe and the Middle East. The traditional materials and methods used for gilding and illumination have been in use for 1,500 years, a sign of their durability.

Initial "S" from the *Psalter of Jean Duc De Berry* from the 13th century.

Design inspiration

Inspiration for designs and ideas can be found in most museums and large library collections and are well worth studying. If this is not possible, there are many excellent books to read. There are also fine examples of modern calligraphy and illumination available, although the function of gilding has changed today. These are crafted pieces of work which cannot be produced by machine. Illuminated scripts can also be found in churches, on Rolls of Honor and Charters, and also used as part of the imagery of prose and poetry.

All illuminated manuscripts are full of a great range of color, design, and pictorial information, as well as technique. As a student you can copy a letter and reproduce it using tracing paper not only matching the color, but observing the techniques of the detail. However, you can create your own examples using the Versal letter, and obtaining pictorial ideas from everyday objects as well as from the natural world by looking at plants and trees.

Gouache

When you are satisfied with a combination of letter and design, trace them onto good-quality, hot-pressed watercolor paper. It may seem expensive, but the results will be much better.

Gouache or watercolor paints should be used to paint the design. Gouache, similar to traditional egg tempera color, gives a denser covering effect than watercolor, and any mistakes can be painted over easily. Gold gouache can be used for the illuminated area, but if you want a really bright effect, there is no substitute for real gold!

When work is illuminated, it simply means that gold or some other precious metal has been added to the image.

Gold powder or shell gold

Gold powder is finely ground gold mixed with gum arabic. Originally, it was mixed in a shell, hence its name. Today it is bought in tablet form in a small palette. It is applied with a pen or brush like paint, and it produces a flat gold which is useful for backgrounds, dots, or fine filigree detail. It will burnish, but not shine.

Gold and loose-leaf gold

Loose-leaf gold is beaten gold. Now supplied in small books of 25 leaves or sheets (23¼-carat gold) it will not adhere to paper or vellum without a gum or size base. Loose-leaf gold is fragile and difficult to handle, but gives the best results. Transfer gold is attached to a backing sheet and is recommended for the beginner.

Gum and size bases

To attach gold to a design, a type of gum is needed. Traditionally, illuminators used a sticky resin called gum ammoniac which produced flat, bright gilding when the gold stuck to it. For a highly polished, raised effect, a plaster-based mixture called gesso was preferred. Both gum ammoniac and gesso produce good results, and were used in the historical manuscripts we see today. However, much preparation is necessary, and it is better to gain experience with more modern mediums.

Modern gum bases on paper

The simplest forms of base glue are PVA and acrylic gloss medium.

PVA is readily available in art supply stores. It can be used thick with a brush or diluted with water for use in a pen.

Acrylic gloss medium is a substance used with acrylic paints to produce a glossy surface, and works well as a glue base for gold.

Gum ammoniac and gesso

Gum ammoniac is derived from a North African plant. It can be bought ready made, but is simple to prepare. The dried raw gum has the appearance of granola (muesli) and contains many impurities. Larger lumps should be broken down before mixing carefully with distilled water. Place the finely crumbled pieces in a small jar, just covering them with water, and stir. Leave overnight. Strain through a fine sieve or mesh stocking into another watertight jar. Do not be tempted to push the remaining sludge through the mesh to gain more glue. It is false economy, as the glue will then contain gritty pieces which will spoil your finished work. The liquid should resemble light (single) cream. The size will dry transparent and you will need to add a tiny amount of either red or yellow watercolor, to color it slightly. It is now time to begin to paint your design where the gold will be. Wash your brush immediately after use.

Ready-made gesso can be purchased by mail order or through calligraphy societies. Experienced calligraphers often prefer to make their own gesso using a mixture of plaster of Paris, powdered lead, brown sugar, and fish glue.

Writing – gilding – painting

It is better to do the writing first, making sure it is correct before proceeding with the gold. Always do gilding before painting because paint also contains gum and therefore gold will stick to the paint and is difficult to remove.

Application of gold

The application of gold is much the same for most of the glue bases used. Before applying the gold, place your work on a hard, cold surface such as a sheet of glass or cold formica. This helps the condensation of your breath to make the glue sticky.

When you use gesso with gold, your work area ideally needs to be both cold and humid to enable the gilder to do it well. Poor results will occur if the atmosphere is too warm or dry.

Paint the design

Painting the design is the final step. Use small brushes and delicate movements. Build up layers of paint, beginning first with a wash then add strong color to the main areas. If you feel that the gold areas are not sufficiently well defined, or if their edges are not crisp enough, outline them with black or dark brown gouache. If the paint retracts from the gold, add a tiny amount of soap or detergent to the paint (a paintbrush tip touched into liquid soap may do). This will break the surface tension and allow the paint to sit on the gold.

When framing the work, make sure the glass does not touch the gilding.

A pencil burnisher is being used here to burnish around the edges of the gesso. Don't go over the gesso or you will leave an indented line.

You will need

Tracing paper

Pencils

Paper (watercolor HP is best)

PVA (craft glue)

Brush for glue

Pen or quill

Brushes and pen for paint

Paints

Transfer gold (backed)

Large soft brush

Burnisher

PVA (craft glue) is available from art supply stores, and transfer gold is easier to use than loose-leaf gold, which makes this method ideal for the beginner.

Gilding with PVA and transfer gold

1 It is good practice to cover your work with paper except the area on which you are working. This will keep it clean and eliminate accidents. Trace the letter and design onto good-quality (140lb HP) watercolor paper.

2 PVA glue can be applied with a brush, pen, or quill. Used in a pen, it should have water added (1:1) to allow you to write. Also add a small amount of red watercolor paint to the glue (making it pink) to allow you to see it on the paper. When using a brush try pulling a small load along rather than painting. Painting creates streaks. Dragging a "blob" keeps it smoother.

3 Begin at one end of the letter and move fairly quickly to the finish. Do not attempt to touch any areas that have begun to dry as this will leave marks. If the finished lines have become grooved, wait till they dry and apply a second coat. Alternatively, apply several thin coats of glue, allowing time to dry between applications.

4 Let the glue dry. This takes about 30 minutes – it will appear matt rather than shiny. Roll a paper tube and breathe over the area to receive the transfer gold. Work quickly because the dampness of your breath on the glue does not last long.

5 Lay the transfer gold face down on the letter and press firmly with your finger. Rub gently but firmly and the gold will stick to the letter. Remove the transfer gold and breathe on the letter again through the tube. Lay the gold again and rub firmly with your finger.

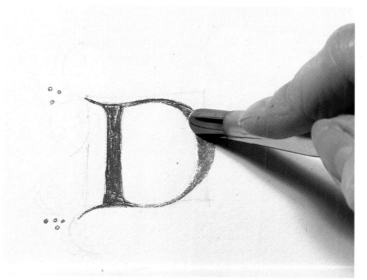

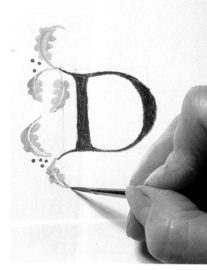

6 Repeat using the tube and use a burnisher to rub the gold down through the transfer paper (a small agate stone can be used). Repeat until no more gold comes away from the backing paper.

7 By using a burnisher directly on the gold, you will see it really shine. If you do not possess a burnisher, a very smooth agate or hematite stone will also work. Begin gently at first. If you feel any "drag," stop. Either the glue is not fully dry (leave it for 30 minutes) or, if you are using an agate stone, it is not smooth enough. Try again.

8 Now that the gilding is complete, the rest of the design can be painted. First brush away any excess gold with a large soft brush to clean up the letter. Begin painting with light washes in the main areas.

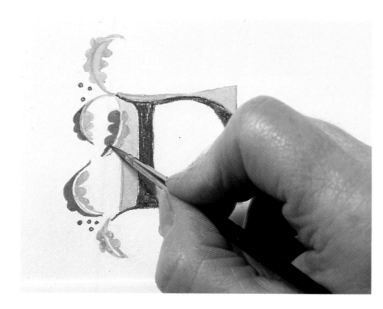

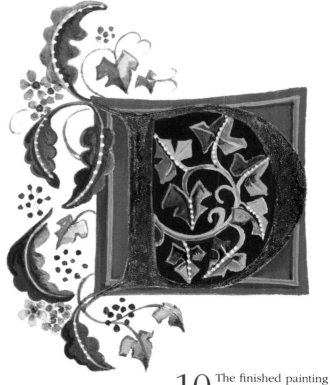

9 Add stronger color as you work, highlighting some areas with white and darkening other areas with thicker, darker color. This will create depth and form in the painting. To define the letter or other areas of the picture, add brown or black outlines around the shapes with paint on a pen or fine brush.

10 The finished painting with the illuminated letter.

Gilding with gesso

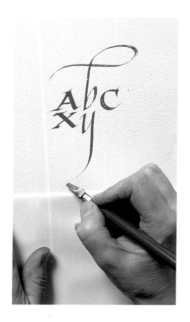

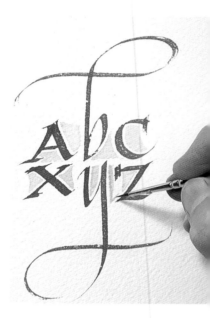

1 Having planned roughly what you want, begin by writing your design. In this case, a combination of capitals and flourished lower-case letters is freely written in gouache; care will have to be taken later to prevent the gold from sticking to it as paint contains gum.

2 Paint in flat areas of color in some of the shapes left by the letters – use very pale, watery paints which will not be competing for attention with the overall design, and which will not attract the gold.

3 Break up a few tiny pieces from a cake of gesso and put them in a tiny container. If the gesso has been made to the traditional recipe containing white lead, take care to wash your hands afterward and store the unused gesso safely.

4 Add two drops of distilled water to the broken-up gesso and leave for 20 minutes to soften. Then add a drop at a time, leaving it to soften further.

5 While it is softening, poke it gently with the handle of a small paintbrush to soften the lumps; prod rather than stir to avoid air bubbles. Aim for a creamy consistency. (Transfer some oil of cloves on a pinhead if air bubbles persist.)

6 Gesso can be laid with a quill, or a pen, or a paintbrush. If you use the latter, it must be wetted, then squeezed dry to eliminate air before dipping into the gesso mix. Lay the gesso by flooding it in, pulling the wet blob along the shape.

7 When the gesso is completely dry, inspect it closely for lumps and crevices. These can be gently scraped with a curved scalpel blade to eliminate imperfections, but take care not to scrape it all off or introduce scratches. However, scraping can also give a "tooth" for the gold to stick to.

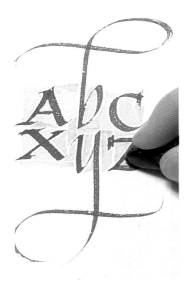

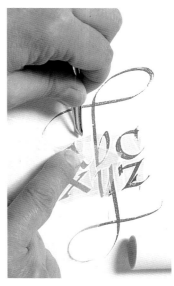

8 You may prefer to make the gesso as smooth and polished as possible before laying the gold, as this can give a shinier final effect. Do not use your best burnisher for this; try a smooth polished stone or the bowl of a teaspoon.

9 Transfer gold is easier to handle, but loose-leaf molds well to gesso so it is demonstrated here. Handle the book of gold by its spine and carefully fold back the pages to take gold from the back; with clean scissors cut a small piece with its blacking paper, and let it fall to the table.

10 Make a breathing tube of absorbent paper and breathe several times over the area to gild; place the work on a cold surface to encourage your damp breath to condense long enough to revive the glue in the gesso. A damp atmosphere is desirable for successful gesso gilding.

11 Pick up the gold either by its backing paper, or with tweezers. Within a second of breathing over the gesso, lay the gold on the area and press it down firmly through the backing paper with your finger. Alternatively, press the gold down through glassine paper.

12 Remove the backing paper if used, lay the glassine paper over the gold, and polish with a smooth implement. Work gently, then more firmly, all over the gold, paying attention to the edges.

13 If you have a burnisher, you can now burnish directly onto the gold and obtain an even greater shine. Start gently and stop if you detect any resistance which may indicate that it is scratching. Protect your burnisher from scratches at all times or it will spoil the gold.

14 When it is completed, use a soft brush gently to remove the excess gold. Scrape carefully if it has stuck to any lettering. If the gold comes off the gesso, the conditions were probably not humid enough, so scrape off all the gold and proceed from stage 8 again in a damper atmosphere.

Index

Credits

We would like to thank the following for kindly loaning us materials for photography:

L. Cornelissen & Son
105 Great Russell Street
London WC1B 3RY
0171 636 1045

Philip Poole & Co
105 Great Russell Street
London WC1B 3RY
0171 636 1045

Falkiner Fine Papers
76 Southampton Row
London WC1B 4AR
0171 831 1151

Quarto Publishing would like to thank all the artists who have kindly allowed us to reproduce their work in the gallery section of this book.

All other photographs are the copyright of Quarto Publishing.